Creative
Approaches to
Painting

An Inspirational
Resource for Artists

Creative Approaches to

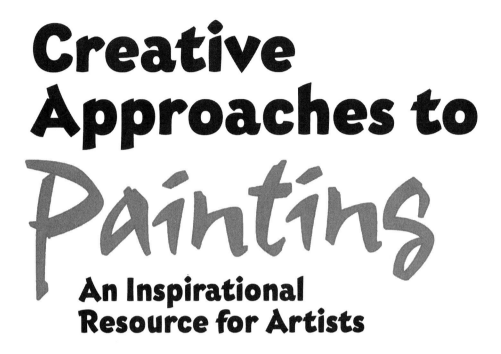

Painting

An Inspirational Resource for Artists

MARJORIE SARNAT

DOVER PUBLICATIONS, INC.
Mineola, New York

Bibliographical Note

This Dover edition, first published in 2018, is a slightly revised republication of the work published as *210 Imaginative Ideas for Painting: How to Find and Keep Your Inspiration and Advance Your Visual Style* by Jr Imagination, Granada Hills, California, in 2013. Trademarks mentioned in this book are the property of their respective owners. All trademarks and product names identified in this book are used in editorial fashion only with no intention of infringement of the trademark. No such use is intended to convey endorsement or other affiliation with this book.

Library of Congress Cataloging-in-Publication Data

Names: Sarnat, Marjorie, author.
Title: Creative approaches to painting : an inspirational resource for
 artists / Marjorie Sarnat.
Other titles: 210 imaginative ideas for painting
Description: Mineola, New York : Dover Publications, 2018. | Series: Dover
 art instruction | "This Dover edition, first published in 2018, is a
 slightly revised republication of the work published as 210 Imaginative
 Ideas for Painting: How to Find and Keep Your Inspiration and Advance Your
 Visual Style by Jr Imagination, Granada Hills, California, in 2013."
Identifiers: LCCN 2018028376| ISBN 9780486824567 (paperback) | ISBN
 048682456X
Subjects: LCSH: Art—Psychology. | Inspiration. | BISAC: ART / Techniques /
 Painting.
Classification: LCC N71 .S19 2018 | DDC 750.28—dc23
LC record available at https://lccn.loc.gov/2018028376

Manufactured in the United States by LSC Communications
82456X01 2018
www.doverpublications.com

This book is dedicated to all artists everywhere,

at any level of experience, who feel the inherently

human urge to paint a painting.

Contents

Preface

This book is about painting ideas, not painting techniques. Any idea can be interpreted in any medium.

It's for anyone who has ever had a desire to paint but wasn't sure *what* to paint. It's for artists who feel painted into a rut, and for artists who are searching for their true and natural style. And it's for painters who wish to explore and expand their ideas and visions. The possibilities are infinite, of course, and no book could ever mention them all.

But I invite you to take an idea that appeals to you and reinvent it in the way that's uniquely yours.

Introduction

As an artist, it's your job to offer the world a new experience—the visual interpretation of life that only you can provide.

Here's a compendium of ideas for finding subject matter that resonates with you, for exploring your creative potential, and for arousing your artistic imagination.

Whether you work in oils, acrylics, pastels, watercolor, hot wax, or whatever it is that makes a mark, the concepts in *Creative Approaches to Painting* apply to you.

As you read through these pages, ideas of your own will flow through your mind. Adapt my concepts to fit with your natural way of seeing or use them as springboards for forming entirely new concepts.

You'll find that some entries contain similar concepts with a differing twist. Others stand alone. For visual examples, I reference art movements or particular artists whose work you can find to view for inspiration.

Creative Approaches to Painting is packed with artistic advice and encouragement. It has tips for naming paintings and for keeping the creative spark burning. Think of it as a tool for discovering your passion and developing your visual voice.

The Art Parts

Part 1, "Identify What Inspires You," is a tour through the landscapes of our outer and inner worlds. It points out many of the signposts from which you can draw your own inspiration and potential subjects to paint. Ideas and inspirations are organized into categories to help you identify what truly calls to the artist in you.

Part 2, "Gather Your Inspiration," offers ways to help you keep a fresh approach to your work, plus guidelines for creating and maintaining both a journal and a reference file tailored to your needs.

Part 3 contains "Creative Approaches to Painting." Read these whether they're listed in your favorite subject area or not, because ideas that appear in one chapter will apply to others as well. The entries are open-ended and allow for adaptations. With art, anything can work in as many ways as there are artists—and then some!

Make this book your own. Write in the margins, tag the pages, highlight the entries, and make notes on the pages designated for jotting down your own ideas.

Finally, in the Appendix is an article about naming your art, along with a Glossary. The Resources section of the Appendix lists useful books, artists, styles, and art supplies.

Let an idea point you in a direction. Then take off on your creative path . . . and leave a painted trail.

Creative
Approaches to

An Inspirational
Resource for Artists

PART 1

Identify What Inspires You

"*T*HE WAY
to make art is to move in
the direction of the greatest
pleasure and excitement."

—JERRY FRESIA

CHAPTER 1

What Should You Paint?

No particular subject matter is more valid than any other. It's your love of the subject that makes it wonderful and worthy of your artistic expression. That which moves an artist to paint varies with each artist, of course, and often varies with each artist's artwork as well. Our motivations are complex elixirs of visual attraction, emotions, thoughts and beliefs, cultural influences, experiences, and a host of other factors.

It's important to know your personal preferences and natural artistic tendencies for choosing subject matter that will sustain your interest and support your personal expression. Consider the following categories to discover if any resonate with the artist in you. Use them as a guide to hone in on your artistic zone. You may need to try various approaches to painting as you learn more about your true artistic self.

Inspired by the Outer World

All you can see around you, from a breathtaking view of the Grand Canyon to an exquisite little ladybug in your garden, offers infinite possibilities for paintings.

Artists who paint tangible subject matter (what you can see and feel) derive their inspiration from the world outside themselves. Such painters work in a range of styles, from photorealistic portrayals to highly abstracted interpretations. Regardless of style, artists who are inspired to depict subjects others can recognize are called representational artists; their artwork represents what exists in our physical world.

Representational subjects fit into three broad categories:

+ **Places—Landscapes:** Landscape themes include all outdoor scenes, seascapes, cityscapes, ancient ruins, building structures, interiors, large inanimate objects in outdoor settings, flowers, trees, rocks, skies, astronomical imagery, and all representations of places and spaces on earth, water, or sky.

+ **Things—Still-life Subjects:** Still-life themes include man-made or inanimate objects, or small confined creatures such as birds in cages or fish in tanks. Anything that can be set up on a table or arranged in your studio (or elsewhere) is a fine still-life subject. Man-made objects like dishes, tools, and cowboy boots or natural items like rocks, flowers, and fruit fit the category. If it sits on a table, if it's indoors, or if it can't leave its place, it can be a still-life prop.

+ **Figures—Human and Animal Subjects:** Figurative themes include portraits, posed figures, nudes, costumed figures, and people in motion, such as dance, labor, and sports. Subjects include animals in natural surroundings, pets, and microscopic life.

Inspired by Your Inner World

Artists who paint the intangible (what is not visible to others) derive inspiration from their internal visions, ideas, beliefs, and emotions. Such painters work in a range of styles, using recognizable forms as metaphors, things that don't exist in our physical world, portraying and using imagery solely from their inner eye. Regardless of style, such artists are called nonobjective or nonrepresentational artists; their artwork does not represent that which exists in the physical world and is visible to others. Rather, their artwork depicts the artists' imagination, thoughts, and feelings about the world.

Subjects that nonrepresentational artists paint fall into myriad categories. Here are a few:

✦ **Beliefs:** Your beliefs are your personal truths, opinions, worldviews, ideology, and strongly held convictions about life and beyond. Belief is associated with spiritual faith as well. Jessica LaPrade philosophizes, "Artists are messengers of great responsibility. The artists of our age are the nomads with the guided path to the future."

Let your brushstrokes flow intuitively until shapes, colors, and abstracted inner imagery emerge as symbolic expressions of your belief system. Or use visual metaphors and symbols to portray your beliefs. Create artwork that others will contemplate.

✦ **Dreams:** Dreams are an endless well of creative inspiration for artists. Dream art is any form of art directly based on content from one's dreams or that relies on dream-like imagery. Paintings inspired by dreams illuminate the intangible.

References to dreams in art are as old as art itself. Either consciously or not, painters of dreams employ visual metaphors, symbolic imagery, and surrealist and expressionist techniques in their work.

Some artists use psychic energy derived from their dreams to express powerful emotions while others explore the true meaning of their dreams through art. Although each artist's dreams are intensely personal, they can touch us all because of their universality—our shared human emotions.

✦ **Emotions:** Emotions play a significant role in artmaking, whether consciously or not. Color choices, the directions of lines, the arrangements of shapes, textural effects, and more reflect emotion. Red, for example, can elicit love, excitement, or anger. You can portray your feelings about any subject or idea through the way you use the elements of art.

The energy you use in the physical act of painting expresses your emotions. For example, smooth blends display serenity, forceful dabs of paint show strong energy, and jagged brushstrokes reveal unrest. Allow your emotions to direct your application of paint.

✦ **Fantasy:** Fantasy art refers to art that depicts images that are recognizable but don't exist in our natural world.

Such images are derived from the artist's imagination. The themes often include science fiction, mythology, mythological beings, mysticism, folklore, magic, spiritual themes, spirit beings, imaginary lands, speculative explanations of the universe, invented creatures, anthropomorphic objects, and a multitude of subjects from the artist's inner eye. Fantasy artists are sometimes called visionary artists.

Realistically rendered imagery can mingle with abstract expressionistic techniques. Intangible ideas can be depicted along with representations of tangible things. Some artists create abstract expressionist works, then find imagery within the paintings to bring into view. Other artists will carefully plan a fantasy concept first, then express it in paint.

✦ **Humor:** Humor is often used by artists to challenge public opinion about art and life. Humorous metaphors, wit, whimsy, parody, satire, stylish cartoons, visual puns, absurd portrayals, and silly nonsense have welcome places in art that's made just for fun—and also in art that *appears* to be fun. As the proverb goes, "Many a truth is told in jest."

✦ **Nonobjective Themes:** Nonobjective art depicts things that do not represent people, places, or things in our natural world. The invisible is made visible. Nonobjective artists manipulate the elements of art in a broad range of styles to express intangible ideas such as beliefs, thoughts, and feelings.

✦ **Patterns and Decorative Imagery**: A pattern is the repetition of specific visual elements or motifs. Every culture and era has a distinct set of patterns and repeated motifs. Patterns are used to decorate, tell stories, create moods, and reference history.

Many artists develop their own sets of patterns that occur in their artworks, sometimes subconsciously. They're created by specific brushstrokes throughout a painting, the repetition of shapes, and applied surface designs. Patterns draw attention and can move a viewer's eye through a composition. Paintings that rely on patterns can be as visually exciting as any other kind of composition.

✦ **Social Commentary:** Artists have used art to make statements about social injustices and to raise social awareness ever since two or more humans first formed a community. Any approach to visual expression can work, from realistically rendered visual metaphors to abstract expressionistic styles. What's important is to create art whose meaning portrays ideas about a social issue.

Pop artist Andy Warhol used his art to address "taboo" topics of his day, such as gender equality, human rights, and the evils of a consumer-driven society. Photographers Arthur Rothstein and Dorothea Lange showed us the desperation of average folks during the Great Depression, and the Ashcan School of Painters revealed the underbelly of New York City dwellers in the early twentieth century. Picasso's "Guernica" depicts the pain and despair that war imposes on innocent citizens. In the 1940s, abstract expressionists used their approach to art as a protest against the established conventions of art and to promote the personal expression of the individual attempting to break out of society's entrapment.

✦ **Surrealistic Ideas:** Surrealist artists create subject matter that the viewer must interpret. The artwork features an element of surprise by positioning objects that don't usually belong together alongside one another. This is called unexpected juxtaposition and dislocation.

Surrealists use distortions of things as they are stretched, melted, or made transparent, and they also use unnatural scales. Another technique includes absurdity and humor, as ridiculous, exaggerated, and nonsensical images are shown. All surrealism is rich with symbolic and dream imagery.

Surrealists compose with collage pictures and renderings of recognizable objects. Their paintings inspire viewers to see ordinary things in new ways.

Note: Surrealists are sometimes considered to be representational artists because their style is realistic, although their scenarios are not realistic. For this book I usually categorize surrealists as nonrepresentational painters, although some overlap occurs.

✦ **Symbolism:** Symbolic imagery is the depiction of things that do not have physical properties, such as words, thoughts, and sounds, as if they were tangible objects. Examples are words pouring out of a faucet or a peace symbol with wings flying into the clouds. It could be depicted simply, such as an ankh symbol sketched against a color field.

Familiar symbols (or icons) such as flags, targets, heart shapes, musical notes, medical symbols, spirals, spiritual symbols, letters, numbers, pentagons, emoticons, and so forth fit in this category.

Symbolic imagery is a visual language that is recognized by many people and that nonrepresentational artists often employ to help communicate their ideas.

✦ **The Unknown:** This subject matter illuminates the unknowable, little-understood phenomena, and mysterious truths yet to be revealed. It depicts the psyche, imaginings, conjecture, supernatural stirrings, sightings, essences, beliefs, spiritual experiences, otherworldly encounters, invisible beings, eerie presences, and thoughts from deep inside the artist's mind.

Paint this subject as tangible substance or portray it in an abstract style. Only the artist knows how it should look. Viewers will interpret the art through the prism of their own beliefs and experiences.

✦ **Words and Messages**: Words have power; they influence us deeply. Consider painting the written word itself. Use words and phrases from literature, song lyrics, poetry, and personal writings. Paint love letters, complaints, insights, wishes, text messages, graffiti, scripture, proverbs, humor, and other fragments of language. Create paintings from inspiring or enigmatic phrases. You can also mix imagery with words and letter forms in your paintings.

The meanings of the words can be what your painting is about, or your painting can be about the appearance of the letters as repetitious patterns or single design elements. "A picture is worth a thousand words," yet one great word alone could be worthy of painting.

SEE RELATED IDEA 130, "A WORD ABOUT ART," ON PAGE 87

Inspired by Both Outer and Inner Worlds

Perhaps you're drawn to the appearance of something tangible, but you'll paint it in a way that shows your emotional reaction to the subject. You represent reality according to your personal interpretations. Or maybe you use the appearance of something in the tangible world as a metaphor for an emotion you wish to express.

For most artists the process of combining motivations happens intuitively. You can't always analyze why you make art as you do. What's important is to keep painting what you love. Trust that the meaning in your artwork somehow will always come through.

Subjects that combine both representational and nonrepresentational themes are infinite. Virtually any being, object, or place fits into this category, as long as the artist's inner world (emotions, ideas, and beliefs) is expressed along with it.

The artist's inner and outer worlds can be depicted in any style, such as photorealism, impressionism, abstractions, and every wild or stylized manner imaginable (or not yet imagined). In this vast category, skill and creativity are your guides.

Inspired by Visual Elements

Most artists enjoy the visual qualities of art, often referred to as formalism, apart from representational concerns. For example, an artist may be thrilled by the color of the model's hat, separate from the "hat" subject matter. The color itself is entertaining to the eye and poses an exciting challenge for use in a painting.

In the Op Art movement, artists were purely concerned with creating optical illusions on the flat surface. In the *Homage to a Square* series of paintings, Josef Albers (1888–1976) addressed only color relationships. Focusing on an element of art, as these masters did, is a valid endeavor in painting. Although it's an intellectual, rather than a feelings-based, approach to painting, the final artwork often elicits strong emotion.

"When you see how each color helps, hates, penetrates, touches, doesn't, that's parallel to life."—Josef Albers

The Seven Elements of Art

These seven elements of art are the ingredients of greatness. They're present in all artwork regardless of style. Great works of literature were written using only 26 letters of the alphabet. So, too, were great works of art painted using only these seven elements.

1 **Color:** The use of hue, value, and intensity in an artwork. Every color has three qualities: hue (the color family, such as red, blue, etc.); value (how dark or light the hue is); and intensity (the brightness or dullness of the hue, such as neon pink vs. dusty pink). Being aware of the range of possibilities helps you make better color choices for your intended expression.

2 **Form:** Shapes used to create the illusion of three dimensions, such as cubes, spheres, cylinders, etc. The use of shading (using a hue's values to suggest light and shadow) can enhance the illusion. Form usually refers to a clearly depicted area that shows height, width, and depth. Attention to form helps you define things in your painting.

3 **Line:** A thin mark or direction that spans a distance or path between two points. A line can curve, zigzag, or take any turn along the way. It can describe shapes, textures, and edges of a form. Line is one-dimensional and can vary in width and direction in an artwork. Use line to create a visual path that leads the viewer's eye through your painting.

4 **Shape:** Two-dimensional areas that are defined and usually enclosed by edges. Shapes can be geometric, such as squares, circles, and octagons; organic, such as blobs of paint, puddles, and squished things; or jagged,

irregularly enclosed shapes. Shapes that are not geometric or symmetrical are often referred to as a free form. Interesting shapes and groups of shapes make for interesting paintings.

5 **Space:** The area within the limits of an artwork's surface. Space includes the background, middle ground, and foreground in a painting and also refers to the areas around, between, and within the things shown. Space creates illusions of distance and depth. There are two types of space: positive and negative. Positive space represents subject matter; negative space is the space around and between the positive space (subject matter). Well-designed negative space supports the positive shapes and contributes to successful paintings.

6 **Texture:** The tactile quality of a surface. There are two ways of expressing texture: visual and tactile. Visual texture refers to the illusion of an uneven surface by giving the appearance of tactile surfaces, such as fuzzy, rough, or pebbly. An illusion of texture is achieved through painting but is actually smooth to the touch. Tactile texture refers to the actual feel of a surface. The surface is not smooth to the touch but has higher and lower fragments covering a surface. Tactile texture can be achieved through the substrate itself, such as rough wood, rusty metal sheets, or prepared textures on canvas. Applying heavy-bodied paint with various brushes and tools and mixing paint with texturizers such as sand, gravel, and fibers add tactile texture. The possibilities are infinite and fun to explore.

7 **Value:** The use of light and dark and the range between them in an artwork. Value is sometimes referred to as tone or shade (darker) or tint (lighter). The lightness and darkness used in an artwork shows form and space by suggesting the way light falls or casts shadows on a subject. The knowledgeable use of value is powerful for creating a dimensional illusion on a flat surface. Value is also related to contrast. Black, the darkest value, next to white, the lightest value, has maximum contrast and usually commands attention within an artwork.

Your Visual Attraction

The elements of art are inherent in both our surroundings and our imaginative vision. Reflect on whether one or more of these qualities holds an important key to your inspiration. If so, experiment with paintings that explore that element.

Mixed Motives

Artistic motivations are usually multifaceted. Suppose you're enthralled by the majestic beauty of a mountain (outer world) and you also wish to express feeling humble or frail in its presence (inner world.) Your love for texture (an element of art) further inspires you to paint the subject. Determine if your motivations feel equal to each other or if one is more intense.

It's possible that your motivation will vary with each of your paintings. Or your passion may evolve from one kind of inspiration into another as you continue to develop a body of artwork.

For example, a colleague of mine was drawn to the look of weathered barns in the rural Midwest. Ed painted barn after barn, becoming increasingly mesmerized by the appearance of large stately shapes dominating flat terrains. His attraction to barns gradually became overshadowed by his fascination with large shapes. As time went on his paintings evolved into superb abstractions, whether or not a barn was discernable.

Every motivational mix is valid. You don't need to be a purist. The key to finding your artistic strength is to identify your personal preferences and stay true to those natural ways.

The Love of Painting

Woven through the medley of artistic inspirations is love for the act of painting itself: the gratification of applying color to surface. We artists relish the look, feel, and smell of our materials; we like the physical rhythm of painting; and we're spellbound to see what happens. Devotion to your artistic quest comes from enjoying the process enough to put in hours and hours of practice.

There are no shortcuts. Books, tips, demos, classes, and gallery visits will support your endeavor, but there's no substitute for painting your paintings. Whether you produce unsightly messes or turn out gems of artistry, what's important is *to paint*.

PART 2

Gather Your Inspiration

"*P*AINTING
is only a bridge
linking the painter's mind
with that of the viewer."

—EUGÈNE DELACROIX

CHAPTER 2

Inspiration Therapy

Every artist goes through periods when their creative spark could use a little boost. There are times when we want to make art but don't know what we feel like painting. Sometimes we search for a connection to a fresh new subject or struggle to tap our passion.

The key to getting out of a creative rut is to get out of the studio. Leave your studio and go on a sightseeing excursion, or leave your studio mentally and go on an imagination excursion. Inspiration is all around, and it will speak to you. The suggestions in this chapter will show you how to relax and enjoy some inspiration therapy.

A Treasure Hunt, a Scavenger Hunt, and a Day at the Beach

✦ **Go Shopping for Ideas . . . and Bring Your Journal:** Go to trade shows, exhibitions, antique malls, specialty stores, thrift stores, garage sales, flea markets, farmers' markets, and swap meets. Go anywhere and everywhere that you'll encounter visual stimulation. Snap photos, and make notes and sketches in your journal.

✦ **Take a New Look at the Same-Old:** Look around your own backyard, your kitchen, your local grocery store, and your studio. Try a new way to portray familiar sights, such as with offbeat colors, unusual views, materials you haven't used before, a style you haven't tried before, or combinations. Focus on only one square inch of a view, then imagine it enlarged on a huge canvas, exaggerate the colors, or repeat the imagery in a pattern. Find an unexpected way to portray an expected subject.

✦ **Observe Nature:** In addition to the grand scale of nature, look for unusual details and vantage points. Find inspiring imagery at the beach, in the mountains, in the woods, in a field of wildflowers, in a garden, in a snowy field, and so forth. A feather, a flower petal, or a few pebbles are amazing subjects to paint. Get some binoculars and go bird-watching to see things you normally couldn't observe. Consider portraying nature from a bird's-eye view or even an ant's-eye view.

✦ **Visit Museums:** Fine art, natural history, archaeology, and science museums as well as planetariums, aquariums, folklore displays, fashion history collections, and popular culture exhibits are filled with amazing things to learn about. It's impossible for an artist to visit a museum and not come away with new inspiration. Don't overlook smaller museums, such as the Santa Barbara Museum of Natural History, where I saw impressive, one-of-a-kind Chumash Indian artifacts. Smaller towns often have superb exhibits about local topics.

✦ **Spend a Day in a Public Library:** When you visit a library, you'll accidentally encounter more than you're likely to see online. Because electronic browsing is deliberate, it bypasses many serendipitous finds you would never think to look for. Browsing through shelves filled with emotions, thoughts, and facts is an exciting treasure hunt. Every volume is a world unto itself. I love to go deep into the shelves, pull out a book at random, and peek inside. My best ideas have come from the pages of unusual books.

Holding a book in your hands and knowing others before you have held and read it makes you feel connected to humanity. The library is a community hub where people and ideas come together; it's uplifting to be among others who are seeking ideas. By the way, libraries are ideal places for sketching people. The ambience is serene, and there are comfortable tables, good lighting, and an array of characters around you to sketch.

✦ **Look at Masterful Artwork:** Get out and view past and contemporary masterpieces in museums and galleries at least twice a year. The more familiar you are with the styles of various eras and the more insight you have into the artists' intentions, the better you can evaluate and improve your own work. Great artwork has universal and timeless qualities that call forth our personal involvement. Actual paintings have a contagious vitality that photos in books and online can never match. Seeing the brushstrokes of the masters and their range of colors can be moving. As an artist, you're likely to feel a reinvigorated connection to the world of art.

✦ **Read Poetry and Song Lyrics:** A picture is a poem without words, and poems are words that paint pictures. Poetry and the visual arts are intertwined through ideas and imagery. In this sense, poetry includes prose, song lyrics, fragments of poems, haikus, beautiful phrases, and other emotional writings. The world of literature is rich with verbal treasures to spark your creativity. Consider this fragment by e. e. cummings (1894–1962): "somewhere I have never travelled, gladly beyond any experience." There's a series of paintings in those words! You don't have to interpret the words as the poet meant them. Read passages from a variety of poems and see what visions come to your mind's eye.

"Painting is poetry that is seen rather than felt, and poetry is painting that is felt rather than seen."—Leonardo da Vinci (1452–1519)

✦ **Read Great Quotes:** Quotes about life, quotes from artists, and quotes about art are a vast source of inspiration. Consider this quote about art from Leonardo da Vinci: "A painter should begin every canvas with a wash of black, because all things in nature are dark except where exposed to light." This idea led me to paint a darkened abstract with mysterious imagery emerging into the light. To me this quote means more than the way things look; it speaks to the way lives unfold. Here's a quote from philosopher Friedrich Nietzsche that beckons interpretation in paint: "You must have chaos within you to give birth to a dancing star."

✦ **Read Movie Titles and Lines:** Movie titles and lines from movies evoke much imagery, especially if you don't know or think about the movie's content. Consider the following titles: *Alice Doesn't Live Here Anymore, Altered States, All That Jazz, Lulu on the Bridge, The Secret Garden, Field of Dreams,* and *Shadow of a Doubt.* If you were asked to produce art based on any of these titles, does a visual idea come to mind?

Here are some famous lines from movies that can be interpreted many ways in a painting: "May it be a light for you in dark places, when all other lights go out" (*Lord of the Rings*), "We all go a little mad sometimes" (*Psycho*), and "I'd buy that for a dollar" (*Robocop*). Online lists will yield hundreds of creative and colorful movie titles and lines.

✦ **Look Through Book Titles:** Book titles also offer a wealth of words that conjure up ideas for visual expression. Consider these: *Midnight in the Garden of Good and Evil* by John Berendt, *The Unbearable Lightness of Being* by Milan Kundera, *Twin Visions* by Boris Vallejo and Julie Bell, and *The Call of the Wild* by Jack London. Browse novels and book titles at the library and online for titles that resonate with you.

✦ **Consider Science Fiction Ideas:** Learn about the thought-provoking events at Roswell, New Mexico, accounts of UFO sightings, and other mysterious phenomena in both ancient and recent history. This topic provides fascinating concepts to interpret through art. Ideas from science fiction novels and movies will also add to your idea repertoire.

Fantasy and science fiction themes free you from expectations of how things should be depicted. Be inventive with dramatic lighting, impossible structures, unknown beings, and weird environments. Contemporary science fiction and fantasy genre artists such as Julie Bell and Boris Vallejo tend to work in a realistically rendered manner. Other styles can bring a fresh point of view and a powerful look to the subject matter.

✦ **Contemplate Spiritual and Biblical References**: Religious and sacred motifs can be uplifting to both artist and viewer. Art history is filled with spiritual content in cultures throughout the world. Consider ideas inspired by the Bible, saints, angels, and so forth. Age-old religious themes can be beautifully expressed in contemporary styles showing a fresh point of view or in any number of traditional styles.

Religious symbols are compelling design possibilities. Think about creating a series of highly embellished Celtic crosses, ankhs, and other symbols as the subject matter for paintings. Go to a place of worship; the experience may inspire you in more than one way.

SEE RELATED IDEA 75, "KEEP THE FAITH," ON PAGE 67

✦ **Embrace Mythology:** Here there be dragons . . . and mermaids, gargoyles, chimeras, fairies, unicorns, leprechauns, gnomes, witches, warlocks, enchanted frogs, and all manner of mythological and magical spirits. Each of these has a rich folklore history, entwined with classic and contemporary literature.

Mythology taps into something universal in our psychology. Read mythological accounts of the beginning of the world and browse almanacs of magic. You'll discover mysterious ideas and imagery to set your imagination soaring beyond the bounds. Consider creating your own mythology, complete with maps of your hidden worlds.

✦ **Observe the Microscopic World**: There's a thriving world of visual wonder that you can't see without a microscope. Buy a simple one with a batch of slides from a school supply store for less than $100. Microscopes provide endless and fascinating reference for artwork, including abstract compositions. You'll witness amazing shapes, patterns, and tiny organisms. It's surprising how things that are so minute can stretch one's imagination.

SEE RELATED IDEA 92 "REALLY, REALLY SMALL WILDLIFE," ON PAGE 73

✦ **Look Through a Kaleidoscope:** Enter a visual wonderland of ever-changing color prisms and patterns shifting into infinity. The kaleidoscope was invented in 1816 by Scottish scientist Sir David Brewster, who used mirrors to study optics. Kaleidoscopes have been classic diversions ever since.

The 1970s saw a renaissance in kaleidoscope artistry. Today, artisans sell handmade versions that are works of art unto themselves. If you love geometric patterns and multitudes of colors, looking through a kaleidoscope will provide endless inspiration. These optical devices re-create new arrangements in a split second, never showing the same image twice. Find kaleidoscopes in toy stores, online, and at craft fairs.

✦ **Observe Gatherings of People**: Three's a crowd, so grab your journal and sketch them. Capture a moment with your camera. Look out for folks watching a parade, walking around the zoo, observing exhibits in a museum, skating in an ice rink, enjoying the beach, and waiting at bus stops. Attendees at sports events, theme parks, and flea markets and people at airports and the Department of Motor Vehicles offer an endless bounty of visual amusement. Note the variety in people's sizes, shapes, ethnicities, and "fashion statements." (Where are those fashion police when you need them?)

Sketch people in their settings, such as the backs of people looking at paintings in a gallery along with glimpses of the paintings. Illustration artist Norman Rockwell (1894–1978) depicted this in "The Connoisseur." The contrast between the realistic rendering of the figure and the nonobjective imagery in the painting adds an ironic note.

SEE RELATED IDEAS 69, "EVERYDAY PEOPLE," ON PAGE 65; 70, "ART-FRIENDLY GESTURES," ON PAGE 66; 71, "PEOPLE IN ACTION," ON PAGE 66; 72, "CROWDED ART," ON PAGE 66

✦ **Observe Gatherings of Animals**: Nature is alive with beauty and inspiration. Sketch ducks in a pond, flocks of birds, gatherings of butterflies, marching lines of ants, packs of puppies, groups of animals you can see at the zoo, pet stores, and wildlife parks. Binoculars are great for spying on animals. Capture life with a camera. When sketching, go for lines of movement and main proportions of creatures, rather than anatomical details. All living things offer opportunities for great paintings.

SEE RELATED IDEA 89, "A GAGGLE OF GEESE AND A PACK OF ALPACAS," ON PAGE 72

✦ **Enjoy Food**: Artists have been moved to paint food subjects since the first cavemen represented their hunger on cave walls. Perhaps they were humanity's first "starving artists."

The Flemish painters portrayed food in mouthwatering detail in their still-life subjects; you can almost smell their freshly baked bread. Pop artist Claes Oldenburg (contemporary) honored hamburgers with his giant vinyl sculpture. Colorist pop artist Wayne Thiebaud (contemporary) paints coffee cups, pastries, and gumball machines. Pink frosted cupcakes and sprinkled doughnuts are popular contemporary subjects to paint, as are sinfully fattening cakes, slices of pie, and eye-catching dishes of candy. Beautiful bowls of fruit are timeless.

Food-related items can offer visual excitement: silver tea sets, teacups and saucers, earthenware, whimsical salt and pepper shakers, and all manner of ethnic, kitsch, and elegant tabletop items. Vintage and contemporary places where food is served have appealing imagery: cafés, food stands, and bakeries—and the people who visit them—tell tasty stories for artists to paint.

SEE RELATED IDEA 59, "GOOD TASTE IN ART," ON PAGE 61

"IN THE JOURNAL
I do not just express myself
more openly than I could to any
person; I create myself."

—SUSAN SONTAG

CHAPTER 3

Your Art Journal: Keeper of Inspiration

Use your journal as your sidekick, inspiration keeper, and creativity coach. Wherever you go, jot down images and ideas that could be useful. Get in the habit of inspiring yourself daily by reading, writing, or sketching something in your journal.

Inspirations can come from anywhere and will get your creative juices flowing. An inspiration gathered in a moment may well become the foundation for wonderful artwork.

Keep track of your own observations and thought-provoking words uttered by others. Take photos of interesting visions for future reference. Collect things that attract you and check out websites, places, and materials that other people recommend.

Living a creative life means being on a perpetual treasure hunt. Creative ideas are free to collect, yet they become your most valuable commodity as an artist.

Humble Beginnings—or Not

You need something that's easy to carry wherever you go. The type of journal you use is a personal preference. Some artists are inspired by beautiful bindings, and it gladdens their souls to use lovely journals.

I am inhibited by the prospect of sketching into journal finery. To me, the leather-bound and silk-covered journals are works of art, and I worry about staining the covers with paint. I'm reluctant to sketch and write in them because my scrawlings don't seem worthy. I find that such journals discourage spontaneity.

I prefer my humble spiral-bound notebook, onto which I hook a retractable ballpoint pen. Decorate the cover if you wish. It is informal and always welcomes my sketches and notes, however roughly done. For me it has an extra advantage: it's left-hander–friendly because it lies flat. Ringed notebooks, simple sketchbooks, and pouches holding index cards and a clip also work well. Keep your journal utilitarian and remember that it's the content that makes it precious.

Let your journal be a personal helpmate for your creative life. Its role is to support your creative endeavors, capture ideas, and keep inspirations at hand.

Some artists use multiple journals for different topics. You could divide a single journal into various sections. Do what suits you best.

My journal is organized by sheer serendipity. I jot down ideas as they come to me regardless of category. Sometimes I'll photocopy or transcribe pages from my journal to include in other files.

Journal Sections

- ✦ Inspirational words, phrases, and written ideas
- ✦ Visual inspirations such as sketches, pictures of paintings, and photos of landscapes
- ✦ Painting ideas you wish to try, such as "a wild animal who's walking through a flea market" or a painting in variations of white
- ✦ Creative endeavors you wish to try, such as making beads or writing poetry
- ✦ Sketches for new styles
- ✦ Swatches of new techniques with notes

- ✦ Places to go and things to see along with observations of where you went and what you saw
- ✦ Tips and techniques about materials and their applications
- ✦ Insights and impressions of people, art, and life
- ✦ Things you wonder about
- ✦ Books and websites to check out
- ✦ Anything funny
- ✦ Creative and inspiring people you meet or learn about
- ✦ Your emotional reactions to anything in your life
- ✦ Right-brain doodles

Digital Journaling

Smartphones and tablets are ubiquitous in today's world, and chances are you carry one around. They say that the best camera is the one you have with you, and with the powerful cameras on these devices, you can take good photographs very easily.

These devices have photo-organizing apps that sync to your desktop computer. They provide ways to manipulate and print your images so that you can use them as reference for your paintings.

Beyond taking photos, you want the software to emulate what you would do using a traditional journal.

- ✦ Make sure your software or app has the ability to sketch and write.
- ✦ Is the interface well thought out, and does it work for your style?
- ✦ Is color important to you in your sketches? Does your color palette have a wide range of colors?
- ✦ Factor in the cost of in-app purchases to achieve the feature set you require.
- ✦ Can you create tags or categories for later retrieval via search?
- ✦ Overall, how well does it emulate a traditional kind of journal?

If you're comfortable with digital devices in other areas of your life, it may be worth exploring journaling as an artist.

"IF I WERE CALLED ON
to define briefly the word 'art,'
I should call it the reproduction of
what the senses perceive in nature,
seen through the veil of the soul."

—PAUL CÉZANNE

CHAPTER 4

Picture Reference: Your Customized Guide

Creating your own visual reference file is one of the best things you can do to support your artistic quest. You'll be in good company; most of the great masters relied on reference of some kind. Good reference helps you bring your statement to life.

The functions of reference materials:

+ **Inspiration:** The right image at the right time can set your creative wheels in a great new direction for many paintings to come.
+ **Information:** Reference provides the information you need to understand what you are painting, such as the structure of an animal's paw or the anatomy of a tree.
+ **Details:** Reference offers richness of detail.
+ **Style Ideas:** Reference shows variety of styling.

Although pictures of almost anything are available online, amassing your own reference gems is a rewarding habit that has advantages

the internet doesn't provide. Keep an artist's eye out and you'll find a wealth of images you'll never see online. It's creative fun to customize your image collection to meet your unique artistic needs.

If you have the space, get a filing cabinet for organizing your images. Filing boxes with hanging folders are a good alternative. Start with a dozen manila folders, label them with category names, and keep the images in them. Tape small scraps to 8½-inch by 11-inch sheets so they won't get lost in the mix.

Your personal visual library will become an inspiring helpmate throughout your art career.

Illustrated Books

If you have illustrated books, find some shelf space for them so they are handy to use. Organize them by topic. I use Post-it® notes to mark the pages that have pictures I may need, and I label the Post-its with the image subject so I can quickly find them.

Vintage Books

If you have vintage illustrated books, it's a shame to cut out pages. Instead, photocopy or scan the pictures. Place the copies in your files, and write the book name and page number at the top.

Generally speaking, images that were published before 1923 are in the public domain and may legally be used in your artwork. However, there may be exceptions, such as pictures of brands that remain on the market today and images that are still owned and managed by estates, such as Johnny Gruelle's Raggedy Ann. Do some online research, and if you're still not sure if an image is legal to use, don't copy any part of it. You may, however, use it as a great example of color harmony, styling, and other elements.

Where to Find Reference Materials

Look for reference materials everywhere, such as in

+ Advertisements and promotional materials
+ Auction catalogs
+ Fabric swatches cut from thrift store and swap meet finds

- ✦ Fabric swatches bought from sewing stores
- ✦ Gallery promotional materials
- ✦ Illustrated books, old and new
- ✦ Junk mail
- ✦ Museum store finds
- ✦ Magazine clippings
- ✦ Newspaper clippings
- ✦ Parts of packaging
- ✦ Postcards, vintage and new
- ✦ Pressed leaves and flowers
- ✦ Recycled greeting cards and gift wrap
- ✦ Retail catalogs
- ✦ Travel brochures
- ✦ Your own photos
- ✦ Your own sketches
- ✦ Anything and everything you can file in a folder or stash in your studio

Collect images that inspire you, delight you, intrigue you, provide visual information, and speak to you in some artistic way.

Treasury of Imagery

The following categories cover the most popular subjects in art. Keep, eliminate, and add subjects to customize your categories and subcategories to reflect your artistic preferences. Developing a visual reference library is a personal project for each artist.

- ✦ **Abstracts:** geometric, painterly, expressionistic, color fields
- ✦ **Animals:** wildlife, cats, fish, butterflies
- ✦ **Cityscapes:** skylines, street scenes, snowy houses, storefronts
- ✦ **Color looks:** brights, aged-faded looks, southwest landscape colors, earth tones, jewel tones
- ✦ **Ethnic styles:** American folk art, African motifs, prehistoric artifacts, Japanese prints
- ✦ **Fantasy:** fairies, mermaids, dragons, imaginary castles, surrealism, dreams

- ✦ **Figures:** children, women, men, crowds, lovers, parent and child, hands, feet, faces, sports actions, dancers, various poses, and angles of figures

- ✦ **Landscape subjects:** sunny fields, wooded areas, snow scenes, sunsets, skies, gardens, mountains, lakes, tropical settings

- ✦ **Landscape painting styles:** traditional, semi-abstract, impressionistic

- ✦ **Seascapes:** harbors, beach scenes, seashore sunsets

- ✦ **Still-life subjects:** flowers, fruit, antiques, shoes, books, toys, tools

- ✦ **Surface treatments:** marble, wood grain, crackle, raindrops, tie-dye, distressed

- ✦ **Your special themes:** what you love, what fascinates you, what you find beautiful, what you find meaningful

Style File

Keep a file of painting styles and visual concepts you want to explore. Tape small clippings to large pieces of paper so they don't get lost. As your collection burgeons, divide it into categories.

Color Collections

Keep a file of color combinations you like—magazine pages, cosmetics ads, swatches of fabric, free paint color charts and chips from home improvement stores—anything and everything that can fit in a file folder. Great color combinations are valuable references for developing "color stories" in your artworks.

Compositions You Love

Collect compositions you love. Any image that immediately draws your attention does so because the composition—the breakup of space—is appealing. A composition can be beautiful regardless of its subject matter. Keep these on hand to study. Try applying the proportions of shapes and the light and dark value arrangement to your own subject matter.

Idea Bank

Creative ideas are precious things. Keep an idea bank at each "station" where you're likely to think about making art: at your bedside, in your studio, in the kitchen, in the car. Whenever you come across an idea or picture you like, jot it down or tear it out and drop it into your bank. Of course you'll want to keep a notepad and pen at each station.

Any small box that opens easily works well. You can make a bank by cutting a slit into the top of a decorated shoebox. Another system is to get a "receipt spike" and use it to hold sketches and clippings. Empty your banks often and distribute the ideas where they belong in your reference files.

Your Preference Reference

Tape images you like, one each, to large index cards or white paper in a three-ring notebook. A notebook format is especially handy for rearranging images and refining categories as you grow your collection.

Search magazines and the internet for contemporary works, works from art history, and whatever attracts you, be it artwork or not. Maybe it's a photo of an old shack that shows interesting distressed wood textures, an ad for beer with a gorgeous color look, or a catalog page showing a jewelry box with an amazing surface design.

Analyze and identify what it is about each picture that resonates with you. Is it the subject matter itself that draws you in, is it the colors, or does the compositional arrangement attract you? Do you love the style of the artwork, such as lyrical line work or juicy brushstrokes?

Write your thoughts down under each image. You'll probably discover trends among the pictures you like. The more aware you become of your personal preferences, the more likely you are to find the artistic approach that feels right for you.

Keep your images for inspirational reference, and continue adding to your collection as you come across imagery that speaks to you.

PART 3

210 Painting Ideas

"**W**HEN YOU take a flower in your hand and really look at it, it's your world for the moment. I want to give that world to someone else."

—GEORGIA O'KEEFFE

CHAPTER 5

Landscape Ideas

Artists who paint the outdoors are also magicians. They move mountains and bend trees. They change the direction of the sun and spread any color they choose across the sky. They'll make a structure disappear and reappear in another location. While landscape artists are inspired by our world, they inspire their viewers with their new worlds. Here are some ideas to prompt creative landscape paintings.

1 CITY SKYLINES

Regardless of size or location, every city is defined by its skyline. Each skyline has unique shapes and distinctive surroundings. New York, Chicago, Las Vegas, Toronto, Paris, Shanghai, and Sydney have unmistakable skylines.

Cities are often built by an ocean, a lake shore, or a river's edge. Day scenes reflect the building shapes in the water. Night scenes are dramatic with a dark silhouetted skyline against an evening sky. Brightly lit windows offer contrast and pattern and often reflect in the water.

The skyline subject adapts to a wide range of styles such as abstracted geometric compositions, highly detailed "slice of city life" scenes, or romantic, idyllic renditions.

When planning a cityscape painting, try visualizing the rhythm of windows or rows of buildings showing from behind the front skyscrapers. Think about the shapes of shadows on a sunny day and the colors and textures of the buildings as seen on a rainy, snowy, or overcast day.

Consider making up your own incredible metropolis skyline complete with odd skyscrapers, unusual architecture, and unlikely surroundings.

2 CITYSCAPES

Similar to skyline paintings, cityscapes are paintings of any "landscape" scenario within city bounds. They can show interesting combinations of shapes of buildings and structures and a profusion of buildings, as Brian Whelan (contemporary) paints. Or perhaps there's a lone star standing in a field of pavement.

Buildings and city scenes offer opportunities to explore geometric shapes and a range of color harmonies. Top view grids, winding lines of expressways, and the patterns made by multiple windows, stacked Pueblo dwellings, masonry, and bas relief cement motifs are exciting visual reference.

German-American abstract expressionist Hans Hoffmann (1880–1966) painted crisp and brightly colored rectangles that are reminiscent of cityscapes.

3 A NIGHT ON THE TOWN

City night scenes can be dramatic with dark skies and shadowy buildings serving as backdrops for bright lights from windows, neon signs, theater marquees, street lamps, automobiles, the moon, and more. Dutch painter Vincent van Gogh (1853–1890) painted the famous *Starry Night*, depicting a night scene that's alive with color and motion.

4 LIFE'S A BEACH

We are drawn to water—falling, flowing, gushing, swirling, high-curled waves, and rhythmic tides. We long to be near a coastline. A coastline is lovely and peaceful, majestic and mysterious, alluring and rejuvenating. Gazing at a body of water can renew our hope or spark our sense of adventure.

Seascape subjects include calm waters, turbulent storms, lighthouses silhouetted against a sunrise, exotic islands, lazy days at the beach, beach umbrellas, charming seaport village scenes, boats in the harbor, exuberant surfers riding the waves, dreamy sailboats, adventurous clipper ships, ocean liners, and old-time fishermen in action.

Look at the masterful paintings of Winslow Homer (1836–1910), an American artist known for his marine subjects.

Super-realist artist Christian Riese Lassen (contemporary) is known for depicting the sea and sea life both above and below the water in a single painting.

SEE RELATED IDEA 93, "EXPLORING THE DEEP," ON PAGE 73

5 AWE-INSPIRING LANDMARKS

Man-made landmarks are inspiring subjects to paint because they represent the genius of humanity throughout history.

Examples are the Statue of Liberty, Mount Rushmore National Memorial, the Golden Gate Bridge, the iconic Hollywood Sign, St. Louis's Gateway Arch, the Gila Cliff Dwellings of New Mexico, the graffiti-covered automobiles at Cadillac Ranch in Texas, the St. Basil Cathedral in Moscow, the Eiffel Tower in Paris, the Sphinx in Egypt, Stonehenge in England, the Great Wall of China, Machu Picchu in Peru, the Acropolis in Athens, Neuschwanstein Castle in Bavaria, the Leaning Tower of Pisa, and the Dancing House in Prague. You can portray these landmarks your way or invent your own to signify your artistic world. Research the Seven Wonders of the Ancient World and the Seven Wonders of the Modern World. Get ready to stand in awe.

6 NATURAL WONDERS

Scenic splendors in America and around the world display the mysterious magnificence of nature. Examples are Devil's Tower in Wyoming, the Rainbow Bridge in Utah, the Grand Canyon in Arizona, the Northern Lights in Norway, the Niagara Falls in Canada, the mud volcanoes of Gobustan in Azerbaijan, Lake Nakuru in Kenya, Uluru Rock in Australia, the Jeju Island Lava Tubes in South Korea, and Ha Long Bay in Vietnam. They will ignite your visual imagination. Research the Seven Natural Wonders of the World. Get ready to be amazed.

7 BE A CAVE PAINTER

Although prehistoric cave paintings are marvelous, look at caves themselves for inspiration. With dark, deep, and haunting allure, there are caves in every part of the world. These underground treasures have natural beauty beyond your wildest dreams.

The bizarre rock formations, rainbow-colored walls, jagged stalagmites, dramatic stalactites, azure waters, peaceful vistas, and eerie scenery will make you wonder if you're on another planet.

The Jeita Grotto in Lebanon, the Skocjan Caves of Slovenia, Bryce Canyon in Utah, Carlsbad Caverns in New Mexico, the Illinois Caverns, the Cave of the Crystals in Mexico, the Cave of the Ghost in Venezuela, the Waitomo Glowworm Caves in New Zealand, the Eisriesenwelt Ice Cave in Austria, the ice caves in Antarctica, the underwater caves in Fiji, Fingal's Cave in Scotland, and Reed Flute Cave in China will spark your artistic imagination.

Visit a cave if you're lucky enough to have the opportunity. In the meantime the photos you'll find online, in books, on postcards, and in videos are visually exciting. Pick a cave at random; you won't believe your eyes!

8 IT'S IN THE DETAILS

Paint representational landscapes with a detail or two that gives you a clue where in the world it might be or that suggests who lives there. A painting of a pretty cottage is fine, but add a squirrel and a basket of berries and a story begins to unfold. Imagine some appealing or unusual details that can liven up a landscape.

9 DEW A DROP OF ART

Flowers, leaves, and branches often have magical details: dewdrops. Observe color reflections in a dewdrop on a leaf or clear droplets that magnify a vibrant section of a flower petal. For a surrealistic approach, imagine a dewdrop as a crystal ball that shows visions from the future or reveals things unknown.

10 FINE WEATHER FOR PAINTING

Focus on the weather and a season. Details and clues that represent a place and time of year can elicit emotional memories.

Show an aspect of a season that is usually not portrayed, such as a close-up of an icicle dripping from a windowsill, one autumn leaf floating in a puddle, or budding weeds between the cracks of pavement—the first signs of spring in the inner city.

Crisp, sunny fall days and hot, muggy summer days have characteristics that give the viewer a feeling of the season. Tell the season through colors in the landscape, the look of the plant life, props like rakes or fishing gear, and details such as a lethargic dog on a hot summer afternoon.

11 'TIS THE SEASONS

Sketch one landscape onto a canvas and divide the scene into four parts in any configuration you like. Paint each section as if it's a different season, blending one season into another. Or divide the canvas into four parts and paint the entire scene in each of the four sections, each showing a different season.

As another approach, paint each section in a different monotone color to represent the seasons. For example, pink for summer, gold for autumn, blue for winter, and green for spring.

SEE RELATED IDEA 167, "THE SERIOUS SERIES ON CANVAS," ON PAGE 104

12 WATERY COLORS

Rainy days offer opportunities to show special effects, such as water splashing off a bicycle or a picnic table with a drenched tablecloth. Picture cherries and a stray leaf or two floating in a bowl of rainwater. Life isn't always *just* a bowl of cherries.

13 "WEED" ENJOY THE SUBJECT

As the great survivors they are, weeds represent strength and determination. Learn about these wild plants and depict them in their natural settings. Weeds are part of the Earth's green bounty and are as lovely to look at as any other plant. Yellow dandelions look delightful and carry a bit of folklore too. As kids we picked dandelions in the fuzzy white stage and made a wish as we blew the seeded tops into the air. (I don't know if this had any effect on my wishes, but it did have an effect on my nasal membranes.)

If you enjoy plants and nature, try depicting weeds in the style of French-American naturalist John James Audubon (1785–1851). He illustrated and cataloged all kinds of birds and plants in meticulous detail.

14 SHOWCASE ENDANGERED PLANTS

According to conservation botanists, there are currently thousands of plants classified as endangered worldwide. Most have rare beauty or hold medicinal secrets. You can raise our consciousness about these precious plants through paintings.

15 SHADY SILHOUETTES

A tree silhouetted against backlighting, which is a brightly lit background, makes a dramatic statement. Use streaks of bright color, a glowing sun, cloud formations, abstract patterns, or pale landscape backgrounds. If the contrast is strong between a light background and the dark trees, the silhouettes will come into focus.

Tip: If you paint your background first, be sure to keep your brushstrokes flat without impasto so the background surface won't distort the images you paint over it.

Be true to a tree's anatomy. The trunk tapers toward the top, and branches and twigs get progressively thinner. Draw the contours by seeing the negative shapes around them. Observe the shapes made by foliage.

Because your silhouettes have no interior details, their shapes need to be interesting. Trees curve and bend in expressive ways; they have their own body language. Think beyond black silhouettes with hard edges and try multicolored dark values or soften the edges here and there. Try adding other elements to your background or foreground.

SEE RELATED IDEA 73, "SILHOUETTES IN THE SHADE," ON PAGE 67, FOR PAINTING FIGURES IN A SIMILAR MANNER

16 RECTANGLES BY THE LAKE

To paint an abstraction of a landscape, select a view that has a great composition. Of course this is subjective, but look for interesting shapes, a range of values, and a center of interest. Use a viewfinder, or form one with your hands. Take some photos of the view to use as reference for an abstract composition.

Create an abstraction of a landscape by blurring edges of things and merging colors and other elements into each other until they are simplified or not recognizable images. Emphasize lines, colors, and shapes to unify your composition and maintain a focal point.

17 ICY ABSTRACTIONS

Study astonishingly beautiful pictures of glaciers and icebergs in Antarctica, Greenland, and other places around the world. If you didn't know they were ice formations, you'd think they were dynamic abstract paintings. These are nature's own works of contemporary art.

Simplify or enhance jagged edges, explore new color looks, alter shapes, and move them around to create paintings with alluring spaces and gorgeous forms. Add the aurora borealis to the imagery, or find ancient animal forms within icy shapes. The possibilities are endless; your first attempts will be only the tip of the iceberg.

18 PAINTING THE PAINTERS 1

If you like to paint outdoors with others, select a great view but include other painters in your scene, as Impressionists have sometimes done. Artists and easels silhouetted against a colorful sunset offer wonderful picture possibilities.

For a nonfigurative approach, show only an easel with a work in progress within your landscape. The artwork you show on the easel must be your own composition or based on a piece in public domain.

SEE RELATED IDEA 86, "PAINTING THE PAINTERS 2," ON PAGE 71

19 THE POWERS OF ABSTRACT FLOWERS

Select a group of flowers that have interesting forms and colors you like. Sketch them or take some close-up photos to use as reference for an abstracted composition.

Blur edges and merge some floral shapes into each other until larger shapes are formed and flowers are only vaguely recognizable. Emphasize some of the lines, colors, and negative spaces until your artwork is unified into a great abstract composition.

SEE RELATED IDEA 128, "A ROSE IS A ROSE IS AN ABSTRACT BEAUTY," ON PAGE 86

20 BLOSSOMS IN SUNSHINE AND SHADOW

Observe how a flower catches the light. Sketch or photograph it for reference, capturing the contrasts of light and shadow. Select only a small section of your flower, cropping out much of the overall form so that part of the flower with its brightest light and cast shadows becomes an abstracted composition.

SEE RELATED IDEA 128, "A ROSE IS A ROSE IS AN ABSTRACT BEAUTY," ON PAGE 86

21 FUCHSIA SKIES AND PURPLE PONDS

Paint a traditional landscape using unexpected colors. Unnatural colors give landscapes a surrealistic mood and a fantasy quality. Picture a rose bush with lavender leaves and chartreuse roses, a seascape of coral waters, a gold lighthouse, and a turquoise moon in a lime-green sky. Imagine a rainbow-tree forest. Paint an entire scene or only selected parts in unlikely colors. Imagine a realistically painted scene with one off-beat, weirdly colored tree.

SEE RELATED IDEA 133, "SEEING RED—AND LIME GREEN," ON PAGE 88

22 STRIPED SKIES AND CHECKERED PONDS

Paint a traditional landscape filled with mix-and-match patterns. Decorative surface treatments give landscapes an upbeat mood. The style can be richly embellished and jeweled, as were Byzantine artworks. Or have fun with a whimsical style or a folk art look.

Picture a rose bush with zebra-striped leaves and polka-dot roses, a seascape of checkered waters, a leopard-skin lighthouse, a daisy-ring moon, or a paisley forest. Paint an entire scene, or select certain areas to paint in a quilt of patterns.

SEE RELATED IDEA, "PATTERNS AND DECORATIVE IMAGERY," ON PAGE 6

23 I NEVER SAW A PURPLE COW (OR DID I?)

Exaggerate the subtle colors found in the natural world. This applies to landscapes, flowers, clouds, mountains, bodies of water, wildlife, ocean life, and anything else in our natural world. If something is kind of pink, make it "pinker." Even neutral grays and browns tend to lean in the direction of a hue. For example, a gray may have a slight purple cast, and a brown may lean a bit toward orange. Look for hidden color leanings and exaggerate them slightly—or outrageously—for a colorist's expression. Push the colorful envelope.

24 INSTALLATIONS ON CANVAS

Installation artists Christo and Jeanne-Claude contend that the real-life landscapes that they alter through the repetition of everyday objects they place in them have no deeper meaning beyond their immediate aesthetic effect. The artists believe their works offer joyful new ways of seeing familiar landscapes. Christo is well-known for his installation of umbrellas in a Southern California expanse of land. Christo and Jeanne-Claude, and artists like them, are referred to as environmental artists.

Paint an "installation" landscape by starting with a traditional horizontal landscape composition. Dot it with a multitude of umbrellas, lawn chairs, billboards, elephants, upright vacuum cleaners, eight-foot paintbrushes, easels, dress forms, chess pieces, cans of corn, or whatever looks great and tells a good story. Choose one item to repeat throughout your landscape, creating an overall surface pattern that moves the eye rhythmically across the canvas.

25 DWELLING ON DETAILS

The apartment buildings I once thought of as commonplace while growing up in Chicago have exquisite features that I now appreciate. The cement motifs,

intricate brickwork around windows, rhythmic structure of back staircases, linear fire escapes, and brick walls magnificently distressed by the Midwest weather are nostalgic sources of inspiration for me.

Focus on the architectural details rather than a whole building. Details you may find compelling include winding stairways, elaborate woodwork, corners of windows, roof details, cupolas, beveled glass windows, cement bas relief details, arched doorways, shuttered windows, roof shingles, floor tiles, distressed surfaces such as peeling paint, weathered wood, crumbling brick and stone, and cracked stucco. These features reflect our inherent need for dwellings and our emotional relationships with the structures we inhabit.

Look for the wonderful architectural details of museums, churches, castles, office buildings, libraries, theaters, and a hundred more places that shelter us. Go on an architectural treasure hunt with your camera or sketchbook to collect reference for structural paintings.

26 THIS OLD HOUSE

Neglected houses and buildings that are being torn down offer abstract beauty. Observe the exposed vertical and horizontal structural lines dappled with patches of brick and irregular scraps of plaster wall. Sights of destruction are interesting subjects because they can raise many questions in the viewer's mind.

27 GIVE US A SIGN

Add allure to your paintings by including signs on buildings. Curiosity draws viewers in to read the words you put in your paintings. It's okay if the meanings are elusive; they tempt us to decipher the clues. Signs on buildings can be hand-painted, carved into wood, pasted-on posters covering the whole side of a building, neon lights, sprayed graffiti, or anything that shows large letters. Distressed and partly torn-down signs present intriguing backstories for people to ponder.

28 AN ARTIST'S VIEW

Windows are powerful subject matter because they symbolize insight and vision. They represent possibilities and a glance into what is not usually known.

Because we're curious creatures, nothing is more tantalizing than peeking inside others' private lives and seeing what we're not supposed to see. Consider portraying some secrets as seen through a window.

Peeking In

Ideas for painting the subject from the outside peeking in are looking into a large public building, a dark high rise at night with the rhythmic pattern of brightly lit windows, a peek through a window with curtains half-hiding the view, warm light from a cottage window in a winter landscape, a pie cooling on a windowsill, a kitten sunning in the window, and messages traced on a frosty windowpane.

Looking In

Tell a story by adding people, such as folks gathered around a store window yearning for the goods inside, kids peering into a toy store window, silhouettes on a window shade, a family inside sharing a meal, a person leaning out and calling to someone, and a lonely soul gazing out a window.

Window Displays

Store windows hold rich possibilities for visual interest. Imagine bakery goodies, antiques, fashion mannequins, fashion shoes, cowboy boots, bicycles, ski gear, travel topics, books, and imaginary objects we've never seen displayed in windows.

Stories

Windows themselves tell dramatic stories. Picture boarded-up windows, broken windows, beautifully curtained windows, stained-glass windows, hanging crystals that cast rainbows, signs in windows, dark mysterious windows high in a building, and overgrown ivy hiding an opening.

Reflecting Their Surroundings

Windows of a building often reflect interesting things on the other side of the street. This can create captivating juxtapositions of imagery such as the window of a bleak building reflecting friends enjoying a meal at a café across the street, other more interesting buildings, dreamy clouds, or any slice of city life.

29 A LOOK OUT

There is nothing more compelling than the subject of a window inside a room showing a glimpse of the outside. Sometimes there's a lovely landscape that makes us want to escape to the outside. Sometimes the glimpse is a view of harsh weather that makes us feel glad to be inside, warm and cozy. Or it could be the irony I once had in an apartment building: my bedroom window was surrounded by gorgeous floral wallpaper but provided a view of a brick wall.

Imagine views through raindrops on a windowpane, curious things sitting on a windowsill, curtains blowing in the breeze, a landscape seen through the grid of

windowpanes, or ice-crusted windowpanes with the magical imagery that an icy surface creates.

Paintings of windows create the illusion of an opening to the outside when hung on a solid blank wall. This gives such paintings extra importance.

30 IN AND OUT THE DOORWAYS

Doorways are rich in metaphorical significance. They can represent escape, protection, entrances, exits, new beginnings, the passage of time, barriers to overcome, a feeling of welcome, a feeling of exclusion, mysteries to solve, the comfort of home, or spaces to explore.

Doorways in a painting ask the viewer if they are inside wishing to exit or outside wishing to enter. Or are they anticipating someone else entering through the door? Is the door open or closed?

Ancient archways, classical pillared entrances, grand double doors, humble back doors, cozy cottage doors, elaborately carved doors, dilapidated screen doors, ominous dark doorways, mysterious passageways, curious portals, inviting Dutch doors, weathered wood doors, cave entrances, and all manner of entryways and exits offer great opportunities for developing a story in a painting. Have you ever discovered a secret fairy door at the base of a tree?

31 THE GREAT INDOORS

Dollhouses

A dollhouse is a great reference because you can view simplified interiors from almost any angle. Furnish the rooms with the wide array of miniatures available today, or keep rooms empty as statements in themselves. When interpreted in paintings, your interiors will appear to be referenced from life scale.

Art Studio

Scenes inside the artist's studio are replete with alluring props, colorful drips, splatters, oozing jars and tubes, incomplete canvases, and paint-smudged tools. Viewers appreciate getting a glimpse into what goes on behind the scenes in the making of a masterpiece.

Kitchen

Kitchen scenes offer warm and cozy feelings, evoke the scent of comfort food, and suggest family bonding. You may have an entirely different statement to make based on your experiences.

Home Rooms

Living rooms, bedrooms, and other rooms in a home have their own visual character, abstract aesthetics, and emotional triggers.

Other Interiors

Interiors of theaters, cafés, antique shops, pharmacies, shoe stores, candy stores, tattoo parlors, bus stations, museums, libraries, churches, and courthouses are rich with visual narratives. They can have lovely architecture or hold an array of colorful items. Focus on a small section of an interior or depict a panoramic view; either can be exciting. Add people if you wish, and include the details that tell the viewer what kind of interior you show.

Tip: A basic understanding of perspective will help you paint convincing interiors regardless of your style.

32 FURNITURE

Furniture makes great subject matter for paintings because the pieces exemplify design history and their function is connected to our daily lives.

Tip: Break up the look of large shapes by draping colorful cloths and shawls over dressers, tables, pianos, and couches.

Dressers, Desks, and Cabinets

Dressers, credenzas, and desks may be battered antique survivors, sleek contemporary shapes, polished wood artistry with sweater sleeves hanging out of drawers, cabinets loaded with knickknacks, or desks piled with books and papers.

Tables

Tables can be laden with things that tease our senses or baffle the mind. They can display nostalgic objects, hold surrealistic imagery, or be set with silver and porcelain finery. Tables can tantalize us with reminders of foods we love. Tablecloths and tabletop things provide opportunities for painters to use any color story they wish.

Chairs

Overstuffed chairs and love seats show evidence that people or pets have warmed their seats. Wood ladder backs and wire café chairs have great shapes to incorporate into paintings. Chairs offer a wide variety of styles and colors to inspire you; every chair has a distinct character and can take on human-like qualities.

The Case for Books

Books are keepers of ideas and emotions, our most precious and powerful commodities. Visually, books on a shelf provide an artist with repetitious rhythms of shapes and colors, decorative spines, enigmatic and meaningful words, and shelves that can be accented with an unusual object here and there.

Books add elevated character to a home and a sense of escape from dreariness, much the way a window does. They let us travel without leaving home. For these reasons, paintings about books appeal to a great many people. Stanford Kay (contemporary) created a series of paintings she calls *Gutenberg Variations*.

33 NATURAL DAY LIGHT

Natural light sources provide wonderful content for a painting. Observe bright sunlight on any object, the look of sun washing over rocks and outdoor things, the light effects from sunrises, light filtered through trees, sunny reflections on water, reflections on windows, light sparkling off a gemstone, rainy day light effects, rainbows, and sunlight glittering on snow. Each of these evokes a mood, often creates beautiful shadows, and has its own color story.

34 NATURAL NIGHT LIGHT

Natural evening light sources provide rich romantic or dramatic content for a painting. Observe the light effects of sunsets, moonlit scenes, the moon itself, stars and constellations, shooting stars, the Milky Way, moonlight filtered through trees, moon reflections on water, reflections on windows, rainy night light effects, a flash of lightning, moonlight glittering on snow and icicles, moonlight on an ocean wave, the aurora borealis (northern lights), fireflies, and campfires. Each of these evokes a mood, creates mysterious shadows, and has a special range of colors.

35 THE TIME OF DAY

Multiple paintings of the same scene at different times of day are about color changes and differing contrasts. What might seem to be tedious repetition is actually an exploration of light and shadow, and the results can be dramatic.

French Impressionist Claude Monet (1840–1926) is known for his series of 25 paintings of haystacks. He used thematic repetition to show differences in light perception at various times of day, across the seasons, and in several types of weather. The subject captivated him throughout his career.

36 UNUSUAL JUXTAPOSITIONS

Create artwork that uses unusual juxtapositions for its landscape subject matter. This means putting things together that wouldn't be together under normal circumstances. Juxtaposition is a technique used by surrealist and illusionist artists, often in an attempt to unite conscious and unconscious realms of reality.

Beach furniture on an iceberg, a locomotive in a swamp, an apple tree flourishing in a desert, a rosebush in a junkyard, kites among factory smokestacks, diminutive cowboys galloping across the hood of a car, a flamingo on a fire escape, fast-food signs at Stonehenge, icicles covered by wildflowers, and a slot machine atop a garden gate are juxtapositions that leave viewers with much to contemplate.

SEE RELATED IDEA 107, "ODD COUPLES," ON PAGE 80

37 PAINT YOURSELF INTO A CORNER

Street corner scenes tease the viewer, leaving them wondering what's around the corner. Give them a clue, such as the back wheels of a wagon or a little dog's tail disappearing, so they can complete the story of your painting.

Take a walk around your town with a camera or sketchbook to scope out interesting views and ideas of what to show—and what only to suggest. Imagery reflected onto windows, mysterious doorways, and abandoned items on sidewalks add interest to the story.

38 ON TOP OF THE WORLD

Show us the world from a bird's-eye view. Take photos from a plane, look at maps, climb a back stairway, sketch from the window of a tall building, or go on a ride on a Ferris wheel to get reference from above.

The world often looks neatly organized from above and has patterns and shapes that are not apparent from the ground. The top-view vantage point could inspire exciting interpretations in paintings.

39 UP, UP, AND AWAY

Balloons

If you love clouds and skies, consider putting hot air balloons into them. Balloons are our oldest successful flight technology, tracing back to A.D. 220–280 in China. Human-carrying balloons were first publicly demonstrated in France in 1783.

Hot air balloons are still beloved today. Albuquerque, New Mexico, has an annual yearly fiesta with more than 750 balloons, the largest balloon event in the world. Balloons have centuries of decorative traditions and allow artists to put color, design, and imagination into a painting of the skies.

Balloon shapes vary, as do their baskets. Many balloons display flags and other decorative elements. Depict your balloons as distinctive individuals or in colorful groupings. Explore designing the balloon of your dreams.

Aircraft

Aviation art encompasses the magnificent beauty of the skies with soaring symbols of freedom and power. There's a passionate community of collectors for both nostalgic and modern-day aircraft paintings. Learn the anatomy of clouds and aircraft so you'll have the skill to express your visions. Illustrator Jack Leynwood is known for his model-airplane-box cover art, and Keith Ferris is referred to as the dean of American aviation art.

40 WILD BLUE YONDER

Skies and clouds are universal symbols of dreams and imagination. They are classic backdrops for surreal subjects, and clouds are also enjoyed for their shifting shapes and colors. A cloud is as unique as a snowflake. Those of us who see animals, castles, and the Battle of Waterloo in clouds are just a few brushstrokes away from a wonderful artistic expression.

41 CATCHING THE MOON

The moon has always held the power to mystify us. Full moons, crescent moons, blue moons, harvest moons, halos, waxing moons, waning moons, and the phases of the moon have generated folklore, romantic notions, pseudo-science, and wild speculation since humans first gazed in awe at the moon's mysterious beauty.

The subject is rich in symbolic meaning. In pagan literature, the moon represents the goddess. In modern works, the crescent moon represents new beginnings and the full moon is associated with deep emotions. Moonlit landscapes and seascapes are classic subjects in paintings.

In the 1950s, the moon was a favorite topic in science fiction. The brightly shining moon, with all its changing forms, has been depicted in art throughout history and all around the globe.

Spectacular moonscape photos from NASA show surface craters and mountain-like formations that are astonishingly beautiful. Our moon is always there, ready for artistic interpretation.

42 SOMEWHERE OUT THERE

Outer space subjects let your imagination soar. Paint the stars, the planets, the Milky Way, moonscapes, rocket ships, UFOs, comets, shooting stars, constellations, and nebulae, filling in gaps of knowledge with imagination or myth. Or learn what you can to portray our vast and beautiful universe. Visit a planetarium for information and inspiration.

43 ART IN RUINS

Ancient ruins and structures give us a connection to the past that we can feel. They arouse our curiosity and inspire us to contemplate human achievement, our own significance, and the passing of time. How were those magnificent structures built, and what did they look like in their day? How did they come to be destroyed? What did our ancient ancestors know that is lost to modern-day scholars?

Study the eerie Stonehenge; Ayutthaya in Thailand; the lost city of Machu Picchu; the mysteries of Easter Island; the immense, intricate Ellora Caves; and other ancient ruins around the world. These are rich subjects to paint, not only for their aesthetic beauty but because they inspire personal interpretation and imaginative speculation in the artist and the viewer of the art.

44 MANY MINI-LANDS

Terrariums are a great reference for painting landscapes from life without leaving the comforts of your studio. Add tiny accessories such as animal figurines, toy dinosaurs, rocks and stones, or a dollhouse gazebo. You can view your terrarium from any vantage point, and it will appear to be a full-scale landscape when you interpret it in paint.

SEE RELATED IDEA 63, "GARDEN IN A GOBLET," ON PAGE 62

45 TRAIN YOUR ARTISTIC EYE

Trains are a romanticized part of our cultural history and a classic subject of folk music, poetry, and art. Trains tap our emotions more intensely than other methods of travel, evoking nostalgia, hope, power, escape, and adventure. Who hasn't heard a distant train whistle and felt a twinge of yearning to be aboard, bound for another place or another time?

You'll find wonderful landscapes wherever trains go. Think of high bridges across waters, fields of wildflowers, ramshackle parts of town, winding tracks through mountains, lush green hillsides, snowy lands, golden cornfields, desolate stretches of terrain, charming villages, and glowing train lights at night.

Paint steam locomotives, contemporary trains, and trains in the distance curving over hills. Trains have interesting large shapes, rich textures with subtle hues in the sun, and unmistakable silhouettes in the dusk. Paint rhythmically patterned train tracks as viewed from above.

Train Stations

Old train stations are inspirations, both inside and out. They offer a wealth of tales to tell. You'll see interesting folks and aesthetic features throughout. Antique postcards often feature the American train station architecture of Henry Hobson Richardson, who is known for his arched entrances.

Model Trains

If you love train lore, invest in a model train set for reference. There's such a broad array of trains and accessories available that let you create authentic-looking replicas. In a painting, your trains will appear to be life-scale—unless, of course, you *wish* to portray them as models.

Elevated and Subway Trains

Elevated trains have their own brand of urban romance. The routes often come so close to apartment buildings that you can peek into doorways and windows. Sometimes there's a clothesline hanging from window to window between two buildings. Subway stations are great sources for urban motifs such as graffiti and colorful characters. We're always curious about the lives of mass-transit passengers.

46 BEEP BEEP

We Americans love our cars. We form personal relationships with them almost as if they were pets. Our culture has been profoundly influenced by the automobile's invention and proliferation in our lives.

The subject offers artists many opportunities for creative paintings. Consider the romance of the early vehicles that changed our lifestyles, the nostalgia of models long gone, the joys and troubles cars often bring, the memories associated with cars of our younger days, and the automobile's symbolic meanings of power and success.

Visualize close-ups of details, including reflections in chrome, landscapes reflected on shiny fenders, a glimpse from the outside to a secret inside the car, or a surrealistic scene occurring on the hood of the car with hood ornaments that have come to life.

In Key West, Florida, there's a trend to cover automobiles with contemporary folkart. The exuberantly painted taxi/minibus Jeepneys of the Philippines, with passengers crammed in and hanging off the sides, are a delight to behold. They're reminiscent of the hippie flower-power– and peace-sign–painted Volkswagens of the 1960s.

If you think outside the box—the metal box, that is—there are top views of freeway traffic, a car speeding through a rolling landscape, and broken vehicles in junkyards.

American pop culture artist Kevin Cyr (contemporary) paints portraits of old vehicles that have acquired character through age, graffiti, and rust. "In a culture where people are lured by the appeal of status-enhancing symbols, I find so much character in derelict vans," says Kevin.

47 MARITIME ROMANCE

With two-thirds of the Earth covered by water, it's no wonder the sea has always intrigued human dreamers. Ships and vessels are our earliest means of transport, dating back to 2900 B.C.

Maritime painting is a classic genre that depicts ships and the sea. Portraits of ships became popular in the Middle Ages in Europe, and the tradition continued through the ages. Marine art tends to be realistic, but any style can work convincingly as long as you convey the feeling that your vessel is sitting *in* the water—not perched on it. If you paint a sailing vessel, make sure the sails are set in a way that makes logical sense for powering it.

Ships can elicit a multitude of emotional responses when set against radiant sunsets or in turbulent or calm waters—or under mystical evening skies, clear blue skies, or dramatic cloud formations. The subject arouses our curiosity: *What is the ship's destination and why?*

In the spirit of seafaring adventurers throughout history, explore creative new ways to show the romance of ships at sea.

SEE RELATED IDEAS 93, "EXPLORING THE DEEP," ON PAGE 73 AND 4, "LIFE'S A BEACH," ON PAGE 36

"**S**TILL LIFE
is the best school, best
exercise for artists.**"**

—SERGEI BONGART

CHAPTER 6

Still-Life Ideas

A still life offers the vitality of painting from life in the comforts of
your studio. The objects you set up don't move and won't require a
break. The still life allows you to explore a vast array of shapes, colors,
and textures within a consistent light source. This is an effective way
to see shape and form and understand relationships between hue,
value, and color temperature.

Forget those predictable vases that bore you, and set up whatever
delights you. Things that have simple shapes and solid colors are the
easiest to draw and paint, but there are no rules. This chapter will
give you some suggestions to spark ideas.

The principles of good composition apply to your still-life setup.
A pleasing arrangement is the foundation of a pleasing painting
or drawing.

First decide on a vantage point. Viewing things at eye level or from slightly above works well. Study the still-life paintings of French artist Jean-Baptiste-Siméon Chardin (1699–1779) for examples of simple but magnificent still-life compositions.

As with most good compositions, determine a center of interest. Use a large item, something with a lot of detail, an unusual shape, or a stand-out color—whatever will draw attention. Cast your supporting characters around the item to complement and contrast with the star.

Find a flat surface with a non-distracting background. A cardboard box covered with cloth can suffice as a table. A large piece of cardboard draped with cloth provides a simple backdrop. It's easiest to paint a still-life setup that has direct light from a nearby window or lamp.

Play with the placement of objects in your still life, creating comfortable overlaps and varying heights, distances, and sizes. Build around your star object. Set up interesting shapes and repetitions of shapes, and contrast darks and lights against each other. Remember that shadow shapes are part of your composition. Fabrics offer wonderful pattern accents.

Use earthquake wax or floral clay to hold objects in place. Check your still-life composition through a viewfinder frame, which is a rectangle cut into a piece of cardboard, or mimic a viewfinder with your hands.

48 PROPS FOR A STILL LIFE

+ **Things at Home:** Go room to room looking for things that tell a story, such as kitchen utensils, a loaf of bread, small framed photos, lipsticks, perfume bottles, stuffed animals, and even piles of laundry. The phrase "doing your laundry" has a whole new meaning for an artist!

+ **Furniture:** Chairs make compelling subject matter because we associate them with our physical and emotional experiences, including comfort,

waiting, and socializing. The mood can be enhanced by showing evidence of human presence through impressions left in soft upholstery.

Open armoires and cabinets showing their contents make tantalizing subjects. They appeal to our curiosity, as we get a peek at someone else's belongings. Side tables covered with cloths, dishes, lamps, and thousands of traditional or wild possibilities are great story-telling subjects.

A table with a lipstick-stained teacup and half-eaten piece of pie tells a very different story from a table holding a candle and a framed photo of a loved one; a table holding a glass of wine, eyeglasses, and a poetry book; or a table holding a jigsaw puzzle in progress.

Pianos can be accessorized with a piano bench, sheet music, candelabras, framed photos, a metronome, a glass of wine, or a high-heeled shoe. (Why not?)

✦ **Things in Your Closet:** Handbags, multitudes of shoes, a rainbow of scarves, sprawls of hangers, and strings of pearls.

✦ **Things in Your Garden:** Flowerpots, weathered tools, seed packets, watering cans, muddy boots, baskets, rocks, and, of course, vegetables, plants, and flowers.

✦ **Things in Nature:** Fruits, vegetables, pinecones, seed pods, feathers, rocks, pebbles, shells, bones, driftwood, leaves, eggs, nests, branches, and straw.

✦ **Found Objects:** Search flea markets, yard sales, thrift stores, and 99¢ stores for items of any sort, broken or not, that have great shapes and colors or that tell compelling stories.

✦ **Packaged Goods:** Boxes of cereal, cans of beans, bottles of dish detergent, boxed board games, and jugs of automotive oil can add words and design narratives to a still life.

✦ **Toys and Games:** Toys can add nostalgia and fun to a setup, and game boards have interesting patterns and design elements. Consider windup figures, blocks, checkers, checkerboards, sleds, roller skates, dolls, toy animals, and toy vehicles.

✦ **Art Supplies:** Paintbrush bouquets, palettes, crumpled paint tubes, stained paint rags, and small paintings are colorful props that most artists have on hand.

✦ **Shapes or Colors:** Let shapes or colors be your subject. Set up varying sizes of things that echo the same shape, such as dishes; circular items, such as balls, hatboxes, and old phonograph records; or things of various shapes that share a color. Excitement comes from the allover effects and subtle differences you'll portray.

✦ **The Unexpected:** Add a jolt of interest to a traditional still life with something unexpected, such as a toy robot next to a vase of flowers.

49 A BOUQUET OF SHAPES AND PATTERNS

Explore flowers as abstract shapes and patterns as well as lovely subjects in your still life. They'll bring life to your subject matter and provide great color combinations.

Showcase patterns by repeating shapes and contrasting colors, such as dark and light flowers in alternating positions. Shadows under the blossoms create strong patterns.

The shapes of most flowers are hollow cones or a combination of cones and cylinders. You'll also find dimensional spheres and flat circles, ovals, and rectangles. They occur in single blossoms or gathered into an array of visual possibilities.

50 A PAINTING WITHIN A PAINTING

Prop up a small painting in the background of a still-life arrangement. The painting could be in progress. Show art supplies mingled with traditional still-life subjects. Using a painting as an object within your still life brings in imagery that would not ordinarily be part of a still life.

The canvas in your still life could show a landscape for a breath of fresh air among the bottles and teapots. It could be an abstract that adds the contrast of bold color and juicy brushstrokes within the traditional vase of flowers and a bunch of grapes.

51 MUSICAL ART

Musical instruments are beautiful things. Their wood and metal surfaces are rich in color, and their shapes and lines are graceful. Violins, guitars, banjos, accordions, saxophones, harps, bagpipes, tubas, flutes, xylophones, drums, and homespun noisemakers have special stories to tell. The oldest known musical instruments are flutes found in a cave near Germany and are about 42,000 years old. Music connects us with our humanity.

We associate musical instruments with emotion, imagining the music in our heads and the scenarios where the music is played. Put musical artifacts in your still-life setup, such as vintage sheet music, a metronome, or a harmonica, and try adding flowers or other props.

Paint a decorative pattern onto a musical instrument in your composition, or superimpose a landscape on a guitar or violin for a surrealistic message. "Tattoo" a musical instrument. Let a xylophone morph into a striped background or paint a set of tribal drums morphing into jungle motifs.

52 A DAY IN YOUR LIFE

Create a still-life scenario that represents a period of time in your personal life. Include photos, mementos, and familiar objects from that time such as a hat, an apron, jewelry, letters, lipstick, scrapbooks, a coffee mug, cozy slippers, books, and anything else that speaks of that time in your life.

53 TENDEREST MOMENTS

Set up a still life to commemorate tender memories of your child or your own childhood. Include favorite toys, beloved storybooks, special clothing, baby's first shoes, rattles, framed photos, love-worn stuffed animals, juvenile blankets, early artwork, and whatever else represents the loving moments and innocence of a young childhood.

54 PRECIOUS KEEPSAKES

Honor a beloved person in your life (past or present) with a still-life setup that tells their story. Include photos, letters, newspaper clippings, keepsakes, favorite objects, meaningful figurines, jewelry pieces, his or her handicrafts (such as wood-carved animals and embroidered towels), and tokens of accomplishment (awards, ribbons, and trophies). Show the person's endeavors, hopes, dreams, loves, devotions, and whatever else provides insight into his or her personality.

Consider painting a portrait decorated by meaningful objects, or place a portrait in the background and paint it as a prop.

55 GARMENTO-ISM

Select a favorite outfit or garment. It could be a traditional Japanese kimono, grandma's kitschy apron, embroidered bell-bottoms from the '60s, a wedding gown, a prom dress, a teenager's punky T-shirts, or baby's first dress-up clothes.

This subject matter allows for a wide variety of styles and color stories. A garment can be depicted on a solid or printed background and be painted in any style from realistic to highly abstracted. Patterns and details within a garment add interesting visual elements. Clothing as subject matter offers unlimited visual opportunities for developing paintings in a series.

56 WINDUPS, WIRES, WHEELS, AND STEAMPUNK

Mechanical relics from days gone by make intriguing subject matter for art. Mechanical things imply human activity and have historic tales to tell.

Don't think of these items as purely utilitarian without beauty. They often have graceful lines, rich weathered surfaces, and mellowed colors. Consider old eggbeaters, typewriters, dial telephones, windup clocks, windup toys, vintage metal robots, antique cars, sewing machines, and anything your grandparents or *their* grandparents may have used. Scope out swap meets, antique fairs, and garage sales for lovely aged props to paint.

Automatons: Life-like metal and cloth windup figures from the Victorian era were called automatons. Men in top hats ride a seesaw, ladies in bustles walk small dogs, or a Pierrot clown plays a cello. Automatons usually had elaborately detailed bases, showed ironic humor, and were intricate works of art.

Steampunk: Steampunk refers to a design style used in science fiction that is set in the late nineteenth century. The romanticized Victorian steam-powered or mechanical technology of this era produced artfully crafted, intricate metal items such as pocket watches, swiveling telescopes, navigation gear, curious corsets, and complex things made from springs, gears, and wires.

Contemporary artists often take items from past industries (steam power) and deconstruct and reimagine them (punk) in clever assemblages, jewelry, and fantasy artwork. Bottle caps, clock workings, screws, windup keys, and recycled metal ephemera are incorporated into their artwork.

For visual inspiration, see Martin Scorsese's masterful film *Hugo*. The movie is filled with wonderful automatons and steampunk imagery. Italian painter and designer Piero Fornasetti (1913–1988) is associated with exciting steampunk style.

57 REFLECTING ON ART

Painting reflections on shiny things offers the opportunity for subject matter within subject matter. Paint part of a room, a person, or a surrounding pattern in the reflection of a silver teapot, a glass of wine, an eye, an ornament, or chrome on a vehicle.

Experiment with scale and cropping. The subject matter you choose can provide any mood or message. Make the reflected image clear and defined, but above all, make sure it follows the contour of the shiny object. Dutch graphic artist M.C. Escher (1898–1972) is known for his masterful drawings and paintings of reflections.

As an abstract approach, paint squares and simple strokes of color to represent reflections. Every dab of color must follow the contours of its shiny object to be convincing as a reflection.

58 DRIPPING WITH TALENT

Drip colorful streams of paint over bottles, jars, jugs, apples and pears, a vase of fake flowers, and other still-life props. Include a splatter or smudge here and there. Use your painterly subjects in a still-life setup. You could also incorporate paintbrushes and tubes of paint into your setup. Observe how the paint droplets catch the light and create small shadows.

Acrylic paint works well because it dries fast. Use nozzle squeeze bottles filled with paint along with loaded brushes. Experiment to find the best viscosity for dripping. It's fun to paint "paint."

59 GOOD TASTE IN ART

Food is a universally beloved subject. Depicting elegant desserts, bowls of comfort food, and classic dishes as your main subject usually draws interest from viewers. Place edible offerings against patterned tablecloths with interesting table settings or use a unique background. Props such as silly salt-and-pepper shakers and kitschy dish towels are fun to add.

Search antique stores and swap meets for vintage cookbooks and food ads. They usually have realistic or stylized food illustrations that are top-notch in skillful rendering. There's much to learn from these commercial food-art masters.

SEE RELATED IDEA, "ENJOY FOOD," ON PAGE 21

60 RAW BEAUTY

Fruits and vegetables are not just rich with vitamins; they're rich with textures, colors, and gorgeous shapes. They add a note of the present moment and inject life into a still-life setup. Consider painting a single immense apple or artichoke on a large canvas. The inherent beauty of the subject will likely amaze you—and the viewer. A colleague of mine paints two-foot-tall pears. Like people, each pear has unique characteristics.

61 ARTSY SOUP

Find a recipe for vegetable soup. Gather the vegetables and ingredients, and arrange them on a wood or tile surface. Create nostalgic or ethnic styling with props such as pretty soup bowls, pot holders, chopping boards, a large pot and ladle, and cookbooks. Produce "stirring art."

62 ARTSY PIE

Find a recipe for apple pie, cherry pie, or your all-time favorite. Gather the ingredients, including flour bags, cut fruit, scoops of sugar, spices, and a pitcher of milk, and arrange them on a tabletop surface. Don't forget a recipe card. Create nostalgic or ethnic styling with props such as old-fashioned eggbeaters, wooden spoons, rolling pins, mixing bowls, flour sifters, cross-stitched tablecloths, grandma's apron, vintage cookbooks, and anything that adds visual interest.

Artsy Cupcakes: Paint a cupcake-baking theme with baking tins and delicious iced cupcakes.

Artsy Cookies: Paint a cookie-baking theme with cookie cutters, cinnamon sticks, sugar sprinkles, and colorful cookie tins. Goodie art makes good art!

63 GARDEN IN A GOBLET

Terrariums are wonderful additions to a still life because they put an upbeat note of life into a composition. Jumbo goblets, dome-shaped containers, and glass boxes filled with greenery are beautiful themselves and look great surrounded by inanimate objects.

SEE RELATED IDEA 44, "MANY MINI-LANDS," ON PAGE 50

64 ART IN A BOX

Gather boxes of any size and paint them in a variety of solid hues and values. Boxes make fabulous subjects stacked and mingled with other props.

Boxes are great without props too; they provide abstract compositions through shapes, colors, light, and shadows. Explore the ways light falls on various arrangements, finding shapes in the shadows. Have some boxes open at one end to create deep spaces, and compose with the negative spaces in your composition.

65 DRESS FORMS

Small dress forms (6–12 inches tall) are available from stores that sell art and craft materials and are great props you can alter to star in a still life. Use acrylic paint to drip, splatter, dab, pattern, or paint beautiful scenes on them. Cover them with collage imagery and printed words, poetry, fashion labels, clothing receipts, food labels, luggage tags, and ephemera. Drape them with strings of beads, scarves, and colorful ribbons. Cover them with flowers or something offbeat like hardware or bottle caps.

Note: If you have a life-sized dress form, it can be turned into a show-stopping assemblage art statement.

As an alternative to dress forms, use the small wooden mannequins sold in art supply stores. They make terrific props because they can be painted, collaged, and posed in expressive ways.

66 SEEING THOUGH IT ALL

Specialize in painting transparent things, such as a room seen through empty goblets, shelves of books seen through eyeglasses, imagery through crystal balls, clear jars of small things, scenes through a car windshield (raindrops are optional), bottles of mystic potions, little things seen large through magnifying glasses, glass vases that show the stems of flowers, clear eggs around developing creatures, glass slippers, glass houses, clear bags filled with anything, and transparent containers holding whatever you imagine. There's something alluring about containers that show their contents as well as the background imagery.

67 PATTERNED BACKGROUNDS

Paint a patterned background with a simple shape against it. For example, find a length of patterned fabric and drape it over a piece of cardboard to use as a backdrop. Fabric stores offer amazing prints. You can use gift wrap, or pull something off your bed or out of your closet.

Arrange simply shaped solid-colored objects in front of a busy backdrop. Place a large jug against a polka-dot backdrop, cowboy boots and a horseshoe against a floral background, or an assortment of gourds against bold checks. Endless choices are yours to explore.

68 DO THE WHITE THING

Paint an assortment of objects with white acrylic to use as still-life props. Things with simple shapes such as bottles, balls, and boxes work well. Arrange the objects with a direct light falling on them to show light and shadows and showcase subtle reflections and color changes. Experiment with black cloths or bright colors under and behind the props.

Try putting one brightly colored object, such as a red ball, into the white setup. It will cast interesting colors onto the surrounding objects.

Shine colored lights on your white still life by using transparent color gels over a light source; they are available from photography supply stores. The way colored light affects the look of your still life is dramatic and creates great reference for unusual paintings.

"*T*HE PAINTING
rises from the brushstrokes as
a poem rises from the words.
The meaning comes later."

—JOAN MIRÓ

CHAPTER 7

Figurative Ideas

The human form and living creatures have been favorite subjects since prehistoric painters first depicted them on cave walls. Living beings have been creatively interpreted in various styles throughout history.

Paintings of people can be historical, mythological, symbolic, emotional, or imaginative expressions. Artists can move us deeply through portrayals of the human condition.

We're naturally attracted to both human depictions and the beauty of animal life. Here are some ideas to jump-start your next paintings of living subjects.

69 EVERYDAY PEOPLE

Capture everyday people and neighborhood folks in your sketchbook. Include more detail than you would put in a gesture sketch, but select only details that show something about the person's character and presentation to the world. You could include offbeat outfits or other clothing choices, body language, facial expressions, and anything else that gives us a clue into a personality.

SEE RELATED IDEA, "OBSERVE GATHERINGS OF PEOPLE," ON PAGE 20

70 ART-FRIENDLY GESTURES

Gesture drawings can be become finished artwork. Go on location wherever people are up and about, but where you won't be conspicuous. Airports, bus stations, libraries, city parks, zoos, shopping malls, street fairs, and swap meets are good choices. Don't even try to capture details—just go for the main action lines of the pose.

Bring some pieces of colored paper; 8½ x 11 or larger is best, but any size will do. I like to pre-paint heavy paper with acrylics or watercolor in painterly neutral tones. Avoid heavy brushstroke buildup so you can easily sketch over your surface.

Use vine charcoal or a soft pencil to do gesture sketches over your painted surfaces. Later, in your studio, you can alter, unify, and enhance the drawings until a satisfying painting emerges. Varnish the piece as is, or apply the sketch to a canvas, integrating the image on paper within a backdrop painting.

Do not trace your drawing onto another surface for fear of losing its spirit. Nothing compares to the loose spontaneity you'll capture by sketching directly from life and turning your original markings into display-worthy artwork.

SEE RELATED IDEA, "OBSERVE GATHERINGS OF PEOPLE," ON PAGE 20

71 PEOPLE IN ACTION

Sketch laborers, shoppers, ball players, folks running for the bus, people shoveling snow, skaters, skateboarders, and kids skipping rope. Use flowing lines and let the clothing show motion, as it folds, flies, or billows with the figure's action.

To enhance a dramatic gesture in a painting, avoid symmetry, let parts of a figure disappear outside the painting boundaries (for closeups), and create an energetic surface texture with short, quick brushstrokes.

SEE RELATED IDEA, "OBSERVE GATHERINGS OF PEOPLE," ON PAGE 20

72 CROWDED ART

Crowds, mobs, gatherings, waiting lines, teams, huddles, groups, throngs, hanging-outers, congregations, audiences, and assemblies of people make great subject matter because they prompt the viewer to speculate about what's going on.

Several gesture drawings arranged close to each other and overlapping make a good foundation for your composition. Capture the overall shape the people form as a group. Focus on a few individuals with detail if you wish, but think in terms of units of people for your overall design.

SEE RELATED IDEA, "OBSERVE GATHERINGS OF PEOPLE," ON PAGE 20

73 SILHOUETTES IN THE SHADE

Dark silhouetted figures against brightly lit backgrounds make dramatic statements. Use swirling bright color, lively patterns, or subtle pale backgrounds. If the contrast is strong between a light background and dark figures, the silhouettes will read well.

Silhouetted figures capture attention when their body language is expressive. To help draw the contours of your figure, observe the negative shapes around it. Because the figures have no interior details, their shapes should be interesting on an abstract level. Think beyond black figures with hard edges, and try many darker hues and slightly softened edges. Explore putting other elements into your background or foreground.

SEE RELATED IDEA 15, "SHADY SILHOUETTES," ON PAGE 40 FOR PAINTING TREES IN A SIMILAR MANNER

74 PAINTING WITH LOVE

It's a joyful experience to paint a portrait of someone you love. You'll spend much time observing your loved one's features, thinking about their personality, and being flooded with feelings and memories. A drawback is that you may become overly critical of your work because of your heightened awareness of their likeness—which you may see through the filter of emotions.

If possible, work from life for just a short period of time to get a lively start. Then continue with a photo reference. Include clothing and props that are familiar and expressive of your loved one's personality. Refer back to life from time to time to maintain the vitality.

75 KEEP THE FAITH

Saints, angels, Buddha, and biblical religious figures are emotional subjects that connect us with traditions and spirituality. Experiment with dramatic lighting for this theme, including backlighting, edge lighting, or shafts of light falling on a figure.

Although this age-old theme is usually portrayed in a realistic style, it can also be effectively interpreted in abstracted styles.

SEE RELATED IDEA, "CONTEMPLATE SPIRITUAL AND BIBLICAL REFERENCES," ON PAGE 19

76 BARELY THERE

Create a simple, monotone color field painting, but include a barely visible nude torso or part of a nude figure modeled in slightly lighter and darker values. Use *lost edges* and softly blended edges here and there. The figure will subtly emerge from the background as a faint image and an almost-there illusion.

SEE RELATED IDEA 134, "LOSE YOUR CREATIVE EDGE," ON PAGE 88

77 WINDOW PEOPLE

Artists often use windows with people in their paintings as metaphors for places beyond barriers, for seeing into the soul, and to symbolize contrasts between the physical realities of our existence and the freedom of our ideas—even when the ideas are out of reach.

American realist painter Edward Hopper (1882–1967) portrayed people with windows in many of his paintings. He showed isolated people seen through windows, gazing out of windows, or bleached by stark light streaming in from nearby windows.

78 THE HUMAN ARTIST'S CONDITION

Nudes are universal statements that transcend particular references to time and place. Standards of physical beauty, however, change over time and differ for various cultures around the world.

The human form is inherently beautiful, deeply complex, and challenges the artist's creative powers. Nudes, especially women, are beloved subjects in art. Learn the basics of anatomy so that you'll have the tools to say what you wish to say.

Some artists focus on models as real people, depict the unique characteristics of their bodies, and indicate their faces. Other artists showcase rounded organic forms as if the model were an abstract landscape. Some enjoy showing textural contrasts between smooth living flesh and adjacent surfaces like fabric, metal, or wood. The visual drama of light and shadow defining the human form is often the inspiration for figure painters. For many artists, painting a nude subject is a symbolic statement. Whatever your approach, the human form is a compelling subject to paint.

79 HOMEBODIES

Figures in interiors and pictured with furniture tell stories of daily life. Keep interior backgrounds simple, but include enough architecture to suggest a wall, doorway, window, floor, or corner. The architecture should be in proportion to the figure and keep the direction of light falling consistently on the figure and the setting.Remember to follow basic perspective.

Determine whether your figure will appear to belong in the setting or be out of place. Either approach makes a strong artistic statement. A small figure within a large room imparts a lonely feeling, while a close-up is cozy and intimate. There are no rules in art that are set in stone.

80 CELEBRATE THE LIGHT

Candlelight illuminating faces and figures is alluring. A dim single light source can impart a mood of romance, solemnity, mystery, or melancholy. Paint people lighting candles in a ceremony. Candlelight glowing on figures defines their forms in a soft and gentle way. The colors are subtle and tinged with warmth.

81 DANCERS

The lyrical movement of dancers makes them an appealing subject. Gesture sketching is a foundation to build a painting upon. Let your pencil or brush do the sketching, and let your spontaneous marks show in your completed artwork.

Ballroom dancers, ballerinas, and modern jazz dancers look great against abstract backgrounds that suggest spaces. Consider all dance genres throughout the world. Music may help you feel an appropriate rhythm as you work.

Dislocated Dancers: Paint dancers in unlikely places, such as ballerinas in a gas station or tap dancers on the moon. Try dancers doing the tango at Stonehenge, the waltz in a grocery store, Bollywood in a cornfield, or the Charleston on the wings of planes (it really happened), or diminutive Riverdancers on your keyboard. Dislocation is a technique used by Surrealists and creates metaphors for the viewer to decipher.

Find visual reference in old books about dance or pictures and videos online, or visit a dance studio with your sketchbook in hand. Go to a party—but let your pencil do the dancing! Study the masterful artworks of Edgar Degas (1834–1917), whose subject matter was predominantly dancers. Degas was especially identified with depicting the spirit of movement.

82 MUSICIANS

Most people love some sort of music. It helps us feel emotions, think in nonverbal ways, and connect to new levels of consciousness. Music has been an important part of every culture around the world. It's a universal pleasure and salve for the soul.

Musicians are wonderful subject matter for paintings because they move gracefully as they play and often mirror the emotions of their piece through their facial expressions and body language. Portray the relationship of the musician to the instrument in your painting. To maintain the feeling in your artwork, use rhythmic strokes for applying your colors and choose colors that express the mood.

83 FACE-OFF

Faces tell true stories. Craggy, wrinkled faces have witnessed a lot of life, and young hopeful faces are looking forward to life's adventures. All faces have character in their features—but it's in the mind of the beholder, of course.

Within a face, the eyes are usually the main attraction. To make the eyes "pop," save the darkest dark to use only in the pupils. Use the lightest light for a highlight, and put it near the pupil for optimum contrast. The eyes will command the viewer's attention.

Exaggerate any feature for emphasis, intensify some of the natural colors, and try other ways of adding personality to bring out your subject.

Self-Portraits: Studying facial anatomy by painting a self-portrait is convenient because your model is always available. However, it's a challenge to see and depict yourself honestly and objectively.

Express who you are as a person along with your likeness. Use color symbolically or include symbolic imagery. Let your brushstrokes reveal your emotions as you paint the portrait to represent your history, hopes, dreams, and goals. Paint the troubles you tackle, the troubles you run from, your loves, your world, and your spirituality. You'll be amazed by what you discover about your image and your beliefs about yourself. For the most outstanding painted faces you'll ever see, study the works of Dutch master Rembrandt van Rijn (1606–1669). His portraits seem to breathe and blink their eyes.

84 HIDDEN FACES

Human and creature faces make alluring subject matter to incorporate into a composition because faces instantly draw the viewer's attention. We're programmed to notice faces. Body forms in a composition are strong attention grabbers, but secondary to faces.

Do a spontaneous underpainting, moving colors and shapes around to your heart's content. High-contrast colors work well, such as dark umber and pale ochre, but colors that are close in value create beautiful effects too. Use as many colors as you wish, not blending them together too thoroughly.

Acrylics and watercolor are practical for the underpainting, but other media also work. Try pouring acrylic paints over a surface, stamping onto a surface, marbling a surface, or using any method of application that results in a richly varied surface. Next search for large or small faces. Enhance these images with a pen, marker, pastels, or paint. Continue to clarify and unify your composition through glazes and opaque color. The possibilities are yours to explore.

SEE RELATED IDEA 152, "DRIPS ARE NOT DRAB," ON PAGE 97

85 IT TAKES TWO

Multiple figures will appear to interact with each other whether or not you intentionally depict them doing something together. Showing two figures on the canvas prompts the viewer to imagine their relationship. If you leave a clue or two, that's all the more for a viewer to ponder. On an abstract level, make sure the lines and shapes of your figures harmonize pleasingly. Think of the figures as shapes that can create visual excitement within your composition.

86 PAINTING THE PAINTERS 2

If you like to paint outdoors with others and you like to paint figures, select a great view that includes other painters in your scene. Or focus in on one *plein air* painter as your subject. *Plein air* is a French term used to describe painting outdoors. American Impressionists have often put outdoor painters in their landscapes. Artists and easels silhouetted against a colorful sunset offer wonderful picture possibilities.

If you don't yet paint as well as van Gogh, perhaps you can paint van Gogh painting. Consider using any of your favorite artists from before 1920 to depict as they paint their paintings outdoors or in their studios. Don't copy a famous painting exactly, but rather show your interpretation of it as it's in progress. Add the artist's palette, a box of paints, and other details to bring the scene to life.

SEE RELATED IDEA 18, "PAINTING THE PAINTERS 1," ON PAGE 41

87 YOUR BELOVED PET

Your beloved pet, whatever the species, is a wonderful subject to paint because it's loaded with personality and emotional appeal for you, and because all of nature's creatures are so beautifully designed.

Take your own photos to use as reference. Study your pet's anatomy first with sketches from life until you're familiar with its form and body language. Use photo reference along with live observations as you paint your pet, emphasizing the features you love. Include any special details that help tell its story.

88 PAINT A HORSE, OF COURSE

Horses have been familiar subjects in art throughout history in rural scenes, hunting scenes, depictions of battle, horse racing, champion shows, horse-and-carriage transport, and nostalgic portrayals of cowboy and Native American life in the American West.

The magnificent beauty of horses attracts many artists and viewers. Horses symbolize strength and the unbridled freedom that resonates with our souls. Capture their spirit in wild, swirling colors or in loose brushstrokes showing teams of horses galloping across wide-open spaces—the wind blowing through their manes. Paint a realistic portrait of a beloved companion.

Doing gesture sketches from life will familiarize you with horses' graceful lines before you start painting. Explore flowing manes and various poses, such as bucking, galloping, trotting, and jumping. All manner of visual expression in paint is apropos for this emotionally rich subject. Unicorns, Pegasus (winged horse), and carousel horses are imaginative alternatives to consider.

89 A GAGGLE OF GEESE AND A PACK OF ALPACAS

Animals in herds, teams, gaggles, flocks, packs, cackles, prides, bands, pods, colonies, swarms, schools, stampedes, and other multiples make fascinating subject matter. Rather than focusing on each individual creature's shape, observe the overall shape the animals form together as a unit. Select one or two individuals to portray with more detail if you wish, but think in terms of clusters of creatures against large background shapes.

SEE RELATED IDEA, "OBSERVE GATHERINGS OF ANIMALS," ON PAGE 20

90 WILDLIFE

Wild animals are exciting. If you're lucky enough to go on a safari, take photos for painting reference. Maybe you'll catch a glimpse of a deer while camping or see animals in the zoo. Take more photos than you think you'll need for reference; more is never enough! Then you can explore the best way to portray the creatures.

91 SMALL WILDLIFE

Small wild animals, such as lizards, squirrels, and grasshoppers, are masterpieces of Mother Nature's design work. Don't overlook these beauties. Take your own photos to use as reference, and do some quick sketches (could they be anything else?) from life to get a feel for the creatures' body language and spirit.

92 REALLY, REALLY SMALL WILDLIFE

There's another whole world of natural life that is just as rich and astonishingly beautiful as anything you've ever seen with your naked eye. Although you'll need a microscope to look at microorganisms, they also represent nature's wonders. I coined the term *Micro-naturalism* for representational depictions of these microscopic wonders. Microscopic life was first discovered by a lens maker turned scientist, Antony van Leeuwenhoek (1632–1723), who called the beings "Animalcules."

Get a children's microscope from a school supply source. They often come with a batch of ready-to-view slides and instructions for making your own. These provide endless and fascinating references. Perhaps you'll create your own species of "Animalcules" with your pencils and brushes. United Kingdom–based artist Brian McKenzie (contemporary) invents imaginary animalcules, drawn as believable scientific specimens.

SEE RELATED IDEA, "OBSERVE THE MICROSCOPIC WORLD," ON PAGE 19

93 EXPLORING THE DEEP

Sea life includes dolphins, whales, fish, jellyfish, starfish, sea horses (some change colors in harmony with their surroundings), sea turtles, creatures that glow, and all of the amazingly patterned and weird hidden beauties that dwell in the deep. Consider selecting just one genus, such as jellyfish, for artistic exploration.

Pearly iridescent paints and glitters are apropos and fun to try. Mixed media artist Miriam Wosk (1947–2010) used these materials (which many art critics would not approve of) in her astonishingly beautiful paintings of sea-life motifs.

Sea Mythology: Mythological sea creatures such as mermaids, sirens, King Neptune, Triton, sea dragons, and Ashrays—translucent water lovers or "sea ghosts" in Scottish mythology—are fabulous subjects to portray. Depict visions of Atlantis, records of mermaid sightings, ship ghosts, and whispering seashells.

Ocean Lore: Mysteries of the Bermuda Triangle, messages in bottles, sunken pirate ships, and treasure chests arouse our curiosity and sense of adventure.

Additional Inspiration: Visit aquariums to see "unbelievably real" sea life. Look up or listen to the lyrics of old sea shanties online.

SEE RELATED IDEA 4, "LIFE'S A BEACH," ON PAGE 36

94 PRO-FISH-ENT ART

Exotic and colorful fish as they move through the water of a fish tank provide graceful poses for quick gesture sketches and snapshots. Try a few spontaneous color studies to see if they might evolve into fully developed paintings, whether representational or abstracted.

A wide array of tank accessories are available that will further spark your imagination as you develop your underwater imagery into full scenarios.

95 SHOWCASE ENDANGERED SPECIES

According to conservation biologists, there are thousands of animals classified as endangered worldwide. Spoon-billed sandpipers, pygmy three-toed sloths, and snow leopards are among them. Use your artwork to raise our awareness of endangered creatures by telling their stories.

96 HOMAGE TO EXTINCT ANIMALS

Some of Earth's modern-day species are past the point where they can be preserved. Pay homage to the world's lost creatures.

97 PREHISTORIC LIFE

Illustrations of dinosaurs abound in books and movies. However, nobody knows what their surface details looked like. Perhaps they had rainbow-colored horns or weird, fleshy appendages that were not preserved as fossils. Let your imagination run wild with the prehistoric beasts.

98 ART THAT FLUTTERS

There are approximately 20,000 species of butterflies, each with unique patterns and gorgeous color combinations. I think of the winged beauties as fluttering flowers.

Butterflies hold ancient and universal symbolism, most often representing the soul, transformation, optimism, spirituality, and love. Paint them as individuals or in graceful clusters. The species provide endless choices for natural portraits, and the subject adapts beautifully to expressive styles and imaginative variations.

99 OLD MacDONALD'S FARM FRIENDS

If Old MacDonald had an art studio on his farm, it would be a converted barn, of course. Cows, roosters, pigs, and other farm animals make great subjects. These beautiful creatures are loaded with personality. They have amazing shapes and markings and emotional associations for the artist and viewer.

The boxy shapes of cows work well with folksy Americana styles, while roosters and hens seem to be painterly designs already. The critters' settings add to the pictorial possibilities. There are no parameters except for good color and composition choices.

CowParade is an international public art exhibit that began in Zurich in 1998 and is featured in major cities around the world. Fiberglass sculptures of cows are decorated by local artists in a variety of themes and distributed to public places around each city. Consider creating your own farm animal parade on canvas or sculpturally. You don't have to be a Pi*cow*sso; you could be a *Pig*casso or a *Chick*casso.

"**E**very time I paint,
I throw myself into the water
in order to learn how to swim."

—ÉDOUARD MANET

CHAPTER 8

Creative Concepts

Art is about interpretation. It's the artist's mission to show the audience new ways to view things. As discussed in detail in Chapter 1, there are four broad categories of expression in visual art.

+ **Representational** expressions portray tangible things that the viewer can recognize.
+ **Abstract** expressions portray tangible things by abstracting visual elements so that the viewer cannot always recognize things.
+ **Nonobjective** expressions portray intangible things such as thoughts or emotions.
+ **Mixed expressions** portray any combination of representational, abstracted, and nonobjective things.
 Note: The terms abstract, nonobjective, and nonrepresentational are often used interchangeably in art.

This section includes a variety of unusual art ideas across these categories. They'll help get your creative thoughts flowing as you determine your next painting.

100 JUNK DRAWER AND HANDBAG CHRONICLES

Keep objects for reference in your junk drawer or a handbag. A junk drawer holds more, but a bag you carry around might be a better reflection of your day-to-day life.

Every few days, weeks, or months, dump the contents onto the glass of a scanner or photocopier. Cover the glass with clear acetate first so you don't damage the surface. To avoid a lot of black background, place a white cloth over your stuff. Print out some images; be sure to date them.

By accumulating several visual diaries of your junk drawer or handbag, you'll establish a revealing record of your personal life. Create an artwork, a journal, or a series of works from this very personal theme.

As an alternative, take a top-view photograph of the contents of your junk drawer or handbag and use it as reference.

101 EXPLODE A POSY

Find a flower and carefully observe its natural forms, shapes, and colors. Paint it in curving, energetic brushstrokes, letting your emotions choose your colors. Imagine it's beginning to explode, keeping sight of its center. Let petals fall where they may. Consider exploding a whole bouquet.

102 EXPLODE A CONTRAPTION

Find a mechanical device, such as an eggbeater, a bicycle, clock workings, or anything that has moving mechanical parts. Observe its structure and the shapes and fittings of its parts. Paint it in quick, energetic brushstrokes without concern for precise imagery. Imagine your device is starting to explode; let the nails, gears, springs, hinges, bells, and whistles spew out and land where they may.

103 EXPLODE A SUNSET

Observe the blended radiant tones, the light, and the cloud shapes in a sunset. Paint it in swift, energetic brushstrokes, responding to your emotional sense of the scene. Imagine your sunset is starting to explode, and let the colors fragment and fly where they may around the sun. Transform your sunset from placid beauty to an abstract expressionist experience.

104 THINGS FALLING APART

Sometimes things in your life come apart and pieces get scattered everywhere. Portray things that are not quite intact with their parts askew or separated. Imagine a kitchen table set, your car, a favorite outfit, a briefcase, a computer, or a coffeemaker with tenuous stability, a little distorted, and starting to disassemble. Have you ever had a day when nothing around you seemed quite right? If so, then paint it. View the wonderful deconstructivist paintings of American artist T. L. Solien (contemporary).

105 TREES OF A THOUSAND TREASURES

Design decorative or surreal trees that bear unusual fruits, such as symbolic motifs, miniature mandalas, gems, poetic passages, and imaginary fruits and leaves. Their trunks provide opportunities for hidden imagery, and their limbs can curve in expressive, lyrical ways.

Austrian Symbolist painter Gustav Klimt (1862–1918) is known for several of his gorgeous paintings. *The Tree of Life*, painted in 1907, has a jeweled trunk and stylized creatures situated here and there among the many spiraling branches.

106 PROFUSION-ISM

Paint a scene that has a profusion of objects you love. Perhaps it is the formal visual elements that attract you: the colors, the shapes, the repetitive rhythm of multitudes. Maybe the objects themselves hold special meaning for you.

Try imagery from an outdoor swap meet, a farmer's market, or a junkyard. Consider toys strewn outside the toy box, a messy closet, a jam-packed toolshed, empty candy wrappers, discarded gift wrappings, a cluttered art studio, shelves of knickknacks, store window displays, a collection of toy robots, a scattering of keys, a collection of salt-and-pepper shakers, a dessert buffet, a tabletop with fancy dishes and napkin rings, a jewelry caddy hung with strings of beads, a pile of rag dolls, old eyeglasses, stamps, coins, souvenirs from a trip, a collection of folk art figures, stacks of suitcases covered in travel labels, sports paraphernalia, broken dishes, bolts of fabric, a dozen snow shovels, and on and on, as your fancy leads you.

107 ODD COUPLES

Unlikely combinations, sometimes called "dislocations," generate surreal and curious messages. Examples such as delicate porcelain dolls sitting on a haystack, penguins waddling through the desert, a fish swimming through a computer screen, and a bag of potato chips next to a goblet of fine wine are sure to lure viewers in to speculate about their symbolic meanings.

You don't always need to have a clear meaning in your mind when you juxtapose things. Combined objects often assume a life of their own, and the artwork will explain their meaning to both you and the viewer.

SEE RELATED IDEA 36, "UNUSUAL JUXTAPOSITIONS," ON PAGE 48

108 THE INSIGNIFICANT AS MAGNIFICENT

Turn something humble into something magnificent through grand scale. A wildflower, a spool of thread, a piece of crumpled newspaper, a rusty nail, or an old gym shoe will take their place among the most highly revered objects of art when you are finished aggrandizing them. Dramatic lighting, high contrast, and intense colors will add to the visual impact of your subject.

109 PAINTING THE GREEN

Money as a subject elicits high interest from almost everyone. Oversized dollar bills, stacks of coins, pennies in mosaics, play money, satirical takes on money, and ancient money systems all tell compelling tales. Money subjects are strong because viewers are sure to have their own personal associations. The cliché expression "Money is no object" is untrue for an artist. Money is a great object to depict in a painting.

110 FIELDS OF DREAMS

Paint subject matter from your dreams, wishes, and fantasy life. Portray ideas by superimposing an object, figure, or face over a landscape, sky, or field of patterns. Allow some of the background to show through the things in the foreground. Let images emerge from your brain as "the artist within" chooses to let subconscious ideas determine the subject matter.

111 DECAY BOUQUET

As an artist you can show the beauty in things that others dismiss. Decaying flowers have a special beauty with their darkened and brittle curled edges and "earthified" colors. Decaying flowers need not be sad statements but rather symbols of the cycle of life and a return to Mother Earth. They graciously make way for new growth.

112 TURN ON YOUR ART LIGHTS

Artificial sources of light are expressive subjects. Candles, streetlamps, nostalgic gaslights, lanterns, dimly lit hurricane lamps, neon signs, flashlights, computer light, television light, magnificent crystal chandeliers, lights from vehicles, enigmatic UFOs, stage lights, spotlights, and glowing mobile phones cast light in their own dramatic way and offer a story to paint.

113 IN SUNSHINE AND IN SHADOW

When beginning a composition, first determine the direction of your source of light. Then forget about what things are and see only abstracted shapes of light and shadow. Describe the contours of forms with edge lighting or side lighting. Create "light bridges," which are paths of light connecting one shape to another. Include shadows, using them to add interesting shapes and patterns and to enhance the feeling of light. The contrast between light and shadow is a timeless idea in art.

114 SHADOWY MYSTERIES

Create a mysterious mood with long shadows falling across an area of your painting. Even a subject that's lighthearted and fun, such as a gumball machine, can elicit apprehension with witch-finger shadows around it.

115 SHADY VISIONS

Paint a pair of fun sunglasses with reflections of tropical islands, nautical scenes, sporting activities, or any outdoor imagery. The concept works well for surrealistic approaches, such as putting out-of-context-scenes, nonobjective imagery, wild patterns, or visionary subjects as reflections in the lenses.

116 ILLUSION SHAPING

If you love geometric shapes, design a composition of large rectangles or any flat shapes you prefer. Add color and value. Paint shadows under each shape, as if they exist in relief. Add highlights to top edges. Your flat shapes will take on new dimensions. An approach to painting that depicts intangible subjects as if they were tangible is referred to as abstract illusionism.

117 GLAMOUR-LESS SUBJECTS

Artifacts of everyday life include sinks full of dishes, stacks of used tires, piles of scrap metal, empty candy wrappers, disorganized desktops, heaps of laundry, overflowing trash cans, toothpaste oozing out of the tube, and closets in disarray. Other mundane scenes are backyard rubble and assorted whatnot in the trunk of your car. Showing the unglamorous side of our lives humanizes us and connects us to each other.

Study the Ashcan School of painting, an American movement that began in the late 1800s. Artists John French Sloan (1871–1951), William Glackens (1870–1938), and Robert Henri (1865–1929) painted humble slices of life in New York's poorer neighborhoods.

118 FOREVER YOUNG

Children's artwork is refreshing. Juvenile artists use bold applications of color, have an intuitive sense of composition, and tell clear stories in their artwork. There's much to learn from their sincere and direct approach. Many crayon drawings done by kids would pass as professional art if they were done in oil paint on canvas. If you know some artists under ten years old, ask their parents if you could look at their drawings and paintings. Or ask an elementary school when their open-house events are scheduled and view the artwork on display.

Get in touch with your inner child and do a painting in a simple and straightforward manner. Represent things as a child would, which is symbolically rather than realistically. Keep trying. It's not easy to create art as purely as a child does.

119 DOT YOUR EYES

Heighten your awareness of shading by painting a simple subject such as a piece of fruit, a flower, or a face and using light and dark dots to show form. I call this dot-ism. Work on a middle-toned surface, and think of your dots as short brushstrokes. Use light and dark values to designate areas of light and shadow. Mingle the dots to create more values. Spacing dots closer or further apart creates even more values. Use any colors you wish, as long as they are the right value. Your subject will look realistic from a distance because your eye will mix the dots optically. But up close your surface will have dramatic "dot-itude."

When French Postimpressionist artist Georges Seurat (1859–1891) painted *A Sunday Afternoon on the Island of La Grande Jatte*, he introduced Pointillism to the art world. Pointillism is a masterful version of dot-ism. For a contemporary take on dot-ism, see the artwork of Angelo Franco.

SEE RELATED IDEA 197, "CREATIVE CONNECTIONS," ON PAGE 119

120 ORIGINAL ABORIGINAL DOTS

Aboriginal dot paintings are characterized by slightly raised dots painted over flat, earth-colored shapes. Australian artists use color symbolism in their dot paintings: yellow means the sun, brown means the earth, red means the sand, white means the clouds and sky. They usually depict animals and natural forms.

Wood panels, heavy paper, and any kind of board will work well. The springiness of stretched canvases can make it difficult to control your dots.

Cover a surface in large areas of flat color. Apply uniform-sized dots over background areas. Let them flow across one area to another to unify the underlying areas. Add smaller dots for details and larger dots for emphasis. Concentric dotted circles and dotted outlines around shapes are typical of Aboriginal dot paintings. The paint application itself will cause the dots to be slightly raised.

Good dot-maker tools are brush handles, wood dowel tips, and small, narrow-tip squeeze bottles that extrude acrylic paint. I've used a part of a plastic toy that has a rounded plastic tip that I dip into liquid acrylic paint. Experiment to find the tools and paint viscosity that work best for you. Gloss dots over matte backgrounds add drama. Adapt this primitive style to a contemporary version through your personal subject matter and color harmonies.

121 MULTI-MONOTONES

A monotone (or monochromatic) painting is an artwork painted in a single color using a range of darks, lights, and middle tones to show form. Old masters painted gray underpaintings (grisaille) before adding color to a canvas. Many artists use earth tones as a warmer alternative for their underpaintings and as final paintings.

I call the following approach multi-monotone because you use several casts of a single hue. For example, green would include yellow-greens and blue-greens. Blue would include greener blues and purpler blues. These color schemes are not fully analogous, but they move in that direction. Subtle nuances of color become significant in a single-hued artwork. Paint any subject you wish in any color family. Try green, pink, or terra-cotta.

There are various ways to create a range of darks and lights.

✦ Use black or umber to darken colors and white to lighten colors. With this approach, however, your colors may lack vitality.

✦ Avoid black and umber; use your chosen color as your darkest dark, and use white to make lighter values. Note that inherently lighter hues such as yellow will lack contrast.

+ For a richer approach, use your color's complement to mix darks and neutrals and use white to make lighter values.

Paint a series of the same subject in various multi-monotones. Divide the canvas in fours and paint each area in a different hue. You'll see dramatic differences in the moods the colors impart.

Spanish artist Pablo Picasso (1881–1973) painted *The Old Guitarist* in 1903 during his Blue Period. The monochromatic painting is mainly in shades of blue.

122 BLACK, WHITE, AND A POP OF COLOR

Paint any subject in black and white with a full range of continuous tones, as in a black-and-white photo or film noir. Your subject can be rendered smoothly or handled in an Impressionistic manner.

Try warm taupe-neutrals or cool blue-grays. Inject a pop of color, such as one red rose, yellow shoes on a figure, or green tiger eyes. Colors appear brighter when surrounded by neutrals and will command attention in a composition.

For a nonobjective approach, paint a composition in the style of Franz Kline (1910–1962). Then add a jolt or two of boldly colored brushstrokes among the black and white. Franz Kline was an American Abstract Expressionist known for his spontaneous black brushstrokes against white backgrounds.

123 MANDALAS

All round things have a center: the Earth, the sun, the moon, the solar system, flowers, snow crystals, eyes, and living cells. The circle is a symbol of harmony, inclusiveness, unity, infinity, and wholeness.

Mandala is a Sanskrit word for circle. Mandalas have a deep spiritual, cultural, and artistic history. They calm those who view them and are associated with healing powers. The form represents a connection between our inner minds and our outer realities.

In art, a mandala is a circle with a center point from which emanates geometric shapes, organic forms, symbolic imagery, colorful visions, and imaginative subject matter. Mandalas are inspirational subjects for viewers and an uplifting endeavor for artists.

To create the basic structure for a mandala, draw a circle and mark its center with a dot. Create eight evenly spaced sections radiating from the center to the edge of the circle by drawing a cross and an X that intersect at the circle's center point. Fill the sections with imagery, either repeated in each section or not. You can find templates for mandalas online.

124 PUT YOUR ART ON THE MAP

A map is a visual representation of an area. It's a symbolic depiction of space and things in relation to that space, such as lakes, mountains, roads, animals, towns, and bridges. The art and science of making maps is called cartography.

Our earliest known maps are preserved on Babylonian clay tablets from about 2300 BCE. In the Renaissance era, detailed maps were printed with carved wooden blocks. Sebastian Munster, who lived near present-day Switzerland, published *Geographia* in 1540. His work became the ancient standard for maps of the world.

Artists have long been fascinated with the idea of imaginary voyages. They chart their visionary travels with intricate pen and ink, printmaking techniques, and paintings. There's a legacy of artists who chart the realms of outer space as well as lands unknown.

Mixed media artists are visual explorers who use maps as a means of discovery in paint, collage, assemblage, and printmaking techniques. Some artists paint over prints of ancient maps or paint relevant imagery onto modern maps. For example, wine motifs may be painted on a map of France, while souvenir tea towels and vintage scarves often display embroidered or printed maps. Photocopy maps to use them as substrates or elements in artwork. To use a map as a substrate, mount it onto board or a canvas first. Maps also make great backdrops in still-life setups.

Map imagery can depict emotions such as love, with its treacherous waters and false paths as you seek that blissful place. As an artist you have power to re-imagine any territory—be it a land, a neighborhood, the heavens, an emotional state, a wish, an insight, or a memory.

American artist Joyce Kozloff (contemporary) uses maps as subject matter in many ways, including painting maps onto masks. She combines her love for artistic traditions with some activist ideas in her art. Look her up online to see her incredibly beautiful maps.

125 GRAND IMPRESSIONISTS

Enlarge part of a print of a great impressionist's painting 200 to 400 percent or more on a color copier or computer scan. The result will be a wonderful painterly abstract image, and you'll be amazed at how beautiful every brushstroke is. Even under magnified scrutiny, the works of the masters are incredible. These images are rich idea sparkers for abstract paintings.

126 FINE DOODLE ART

A canvas covered with lyrical, spiraling, looping, or zigzagging line-work accented by color creates a mesmerizing mood. Start by using acrylic paint or tinted gesso to cover a canvas in pale colors with softly blended edges.

Keep the surface texture fairly smooth. Use a permanent black marker to doodle over your canvas. Draw spontaneously with your marker or sketch the lines first with vine charcoal before using the marker. Use a soft cloth to remove excess charcoal. Paint accent colors inside the enclosed shapes.

Doodle over your entire surface, creating lines any way you wish. Music may help you make rhythmic lines, or visualize letter forms, the contours of flowers, crumpled paper, or just intuitively feel your way. Committing a doodle design to canvas elevates this personal art expression to serious stature.

127 ALLOVER PATTERNS

Layer a pattern over a nonobjective underpainting. Acrylics work well for this because they dry quickly, but make sure your underpainting doesn't have heavy brushstroke buildup, called *impasto*, so the designs you paint on top won't be distorted.

+ **Underpainting:** For your underpainting create an ombré of blended color changes, wild swirls, or subtle hues. Experiment knowing that anything can work. Let your underpainting dry.

+ **Top Pattern:** Layer a pattern over your underpainting. Use stamps dipped in paint for repetitious motifs, or paint your own motifs. Try painting dots, stripes, or organic line and shapes. Use contrasting values or subtle color temperature changes for the top pattern.

+ **Finishing Effects:** Add more layers of pattern over pattern, or unify the surface by spattering, dotting, or glazing areas. Use an acrylic medium to seal your final artwork.

128 A ROSE IS A ROSE IS AN ABSTRACT BEAUTY

Flowers provide rich reference for abstract shapes and spaces. Use enlarged petals for beautiful backgrounds through blending, blurring, and losing some of the edges. Paint bolder and sharper edges in the foreground. Keep working until the floral subject matter is no longer recognizable and suggests other forms. Incorporate additional imagery into your composition if you wish.

The geometric and organic shapes, spectrum of colors, cast shadows, and leaf forms found among 10,000 identified species of flowers can jump-start a wonderful series of paintings. Stop and smell the possibilities.

SEE RELATED IDEAS 19, "THE POWERS OF ABSTRACT FLOWERS," ON PAGE 41; 20, "BLOSSOMS IN SUNSHINE AND SHADOW," ON PAGE 41; AND 171, "INTERPRET A PASSION," ON PAGE 110

129 ABSTRACT AN AMERICAN CLASSIC: DENIM

Like fine wine, denim gets better with age. The frays, scuffs, stains, and threadbare areas give distinctive character to each garment, while their range of faded blue colors adds to denim's beauty.

Find an old denim item; the more distressed, the better. If you don't have any old jeans lying around, visit a thrift shop. Zoom in on a few square inches of denim to use as the "blueprint" for a composition. Let the denim's markings suggest a focal point. Paint an abstract by either showcasing or obliterating the realistic look of the fabric. Picasso or not, create your own Blue Period.

130 A WORD ABOUT ART

Written words are interesting subjects to paint because they compel the viewer to read them and derive their literal or subliminal meaning.

Letter forms themselves are wonderful shapes. Parts of handwritten letters, enlargements of single letters, and grouped letters or words are visually interesting. Explore numbers and symbols as well as foreign and ancient alphabets. Tell a secret story in cuneiform. American artist Jasper Johns (contemporary) used letter and number forms in his colorful encaustic paintings.

SEE RELATED IDEAS, "WORDS AND MESSAGES," ON PAGE 8 AND 180, "ALPHABETICAL ORDER," ON PAGE 113.

131 MASTERFUL ALTERATIONS

Find an image of a masterpiece that's in the public domain. Reinterpret it your way by selecting parts of the composition to use and alter or by injecting new imagery. Imagine Monet's haystacks with UFOs in the background or Grant Wood's *American Gothic* with tattooed and pierced farmers. Public domain paintings are ripe for parodies and satire but can also be handled as masterful beginnings for compositions you change drastically. There's a long tradition of paintings about paintings.

132 FAUVIST UNDERPAINTING

Create a wild, abstract underpainting that will liven your final statement. Using oils or acrylics, apply colorful brushstrokes over your entire canvas. Do not use neutrals, but rather use a variety of bright hues.

Apply complementary colors over each area. Don't cover each area totally, but let slivers of the underlying colors peek through between brushstrokes. Think only "color" at this stage.

Finally, sketch some compositional guidelines and begin to unify the painting, covering and adjusting areas as needed to create visual focus.

If you like to work representationally, try integrating still-life subjects, landscape forms, or figures into this surface. Creating Fauvist underpaintings is emotionally freeing and results in richly colorful paintings.

133 SEEING RED—AND LIME GREEN

Show red when something is blue. In other words, paint a traditional subject, such as a person, a creature, a place, or a thing, using unexpected and unnatural colors.

Pop Artist Andy Warhol used this technique in his Marilyn Monroe series. Unnatural colors give artwork a surrealistic mood, a fantasy context, and the message of being separate from our natural world.

SEE RELATED IDEA 21, "FUCHSIA SKIES AND PURPLE PONDS," ON PAGE 41

134 LOSE YOUR CREATIVE EDGE

Paint an abstract or representational subject using softly blended edges and some entirely lost edges, as a form melts into its background. Very soft edges create a dream-like mood.

Consider depicting some sharper edges for emphasis. An area of increased definition among soft and lost edges usually becomes a focal point in a composition, as that area seems to emerge forward from its background.

SEE RELATED IDEA 76, "BARELY THERE," ON PAGE 68

135 A PATTERN OF ARTISTIC WAYS

Because strong patterns draw attention, they're effective to use in the center of interest. They can add a jolt of excitement to a placid composition.

Patterns can follow the contours of the objects they are printed on as well as the laws of perspective. For example, a checkerboard floor will have converging lines and smaller checkers as they go back in space. As with any solidly colored object, their colors are affected by light and shadow.

In addition to painting patterned objects, cloths, and papers, look for patterns in unexpected places such as:

✦ **In Buildings**: windows, bricks, and masonry

✦ **In Nature**: patterned fur, reptile skins, flowers, and leaves

✦ **Patterns Created by Multiples of Things:** fields of flowers, stacks of logs, leaves on the ground, heaps of lemons, houses stacked on a hill, gatherings of butterflies, groups of scattered clouds, books or shoes strewn around the floor, and the top view of a box of buttons

Cover any object or figure with patterns and imagery as if you are "tattooing" it. Layer patterns over the surface of a representational underpainting by following the contours for a surrealistic feel, or use flattened patterns for a stylized decorative approach.

136 A NEW POINT OF VIEW

Explore new visual points of view. Look at your subject with a focus on minute details, or paint it larger than life, such as a 4-foot-tall house key. Observe from a bird's-eye view, like an overstuffed chair that may appear as a group of abstracted shapes. Paint a section of your subject, like the handle of a teacup or the stem of a pear.

Observe the things around you from odd angles, and experiment with foreshortening. A traditional subject can become a new statement when presented from an unexpected vantage point.

137 SHAPELY PROFUSION-ISM

Create an interesting shape on your canvas. It can be an abstract shape or a recognizable silhouette, such as a human head, an animal, or a skyline. Fill the interior of your shape with a profusion of small images, such as acrobats, words, flowers, nuts and bolts, shoes, eyes and lips, soup cans, and small geometric shapes. Leave the background fairly solid, but you might want to give it a color or texture that enhances your main focus.

You can add a layer of fascination by revealing form or detail in your larger image when it is viewed from a distance. Small dark and light rosebuds might depict the features of a face when viewed from afar. One way to do this is by using transparent glazes to darken areas of your profusion. If your large image will be a face, use glazes for eye sockets, shadows under the nose, lips, and facial contours. The glaze color goes over the profusion and allows the underlying imagery to show through. Keep the effects subtle, not letting your glazes get too dark at the start. Add darker tones only when necessary.

138 COTTON FIELDS AND POLY-BLEND HILLS

Rumpled fabric on a flat surface forms an intriguing otherworldly landscape. Draped and folded fabric becomes rolling hills or undulating organic forms of the imaginary kind. Sheets, tablecloths, towels, and yardage from fabric stores will work, whether the fabric is printed or a solid color. Add props, such as toy houses, plastic animals, strewn flowers, tossed crayons, crisscrossed ribbons, old postcards, or something unexpected.

139 YOU ROCK

Semiprecious rocks and gems are examples of Mother Nature's design genius. Study the way they catch the light and cast shadows; you'll discover gorgeous abstract "paintings" inside.

Observe gems in detail, or enlarge photos to see hidden spaces, perfect forms, and prisms of color that evoke spiritual imagery, graceful figures, and abstract geometry. Some rocks have layers of minerals in swirling and meandering trails of color.

Quartz rocks are mystical caves with tiny stalactites and stalagmites. Imagine that you're walking through a crystal garden with tall, ascending crystal formations glimmering around you. Minerals offer endless inspiration for visual exploration. It's exciting to create "semi-precious art."

140 THE HEART OF ART

The heart shape has long been used as a symbol for love, passion, tender feelings, mysticism, and spirituality. The geometric motif is traced to ancient Europe, and there are references to the heart as a metaphor for spirituality in the Old and New Testaments.

American Pop artist Jim Dine (contemporary) incorporates his personal passions with everyday familiar symbols. He is known for his painterly hearts, in which he juxtaposes vibrant warm and cool colors. Dine also depicts hearts in repetitive patterns. The heart motif is a classic subject that adapts to myriad imaginative styles for paintings.

141 TIMELESS TREASURES

Vintage jewelry provides fascinating imagery for interpretation. Scan or photocopy jewelry pieces, and make prints of them to use in collages. Incorporate beads, jewelry parts, and small pieces of hardware. Enlarge prints of jewelry to mammoth scale as the foundation of an interpretive painting.

SEE CHAPTER 11, "DEVELOPING A SIGNATURE STYLE," ON PAGE 107 FOR ADDITIONAL CREATIVE CONCEPTS

142 ABSTRACT REFLECTIONS

Find a cut crystal vase or a clear drinking glass with an interesting surface texture. Position it so it catches light and reflections, then take a photo of it. Cut a postage stamp–sized window in a piece of paper to isolate an abstract composition within your photo.

Enlarge your composiiton, either visually or with a projector, onto a canvas. Now you have the foundation of an abstract painting, rich with beautiful shapes, colors, and value changes.

143 LITTLE WINDOWS GET BIG RESULTS

A postage stamp–sized window cut into plain paper makes a great tool for finding abstract compositions within magazine ads, old photos, and more. Isolate an area through your window so that the original subject is no longer recognizable, and voila! You have an intriguing abstract composition to inspire a painting. Try several compositions found within the same image to create a series of abstract paintings. Experiment with the size of your window; a slightly larger size may work better for you.

"*R*EALISM AND naturalism rely mostly on the eye of the flesh. Abstract, conceptual, and surrealistic art rely mostly on the eye of the mind. Great works of art rely on the eye of contemplation, the eye of the spirit."

—ALEX GREY

CHAPTER 9

Innovative Materials

The introduction of new materials and techniques, especially the nontraditional, helps drive change in the art world. In the early twentieth century, Pablo Picasso and Georges Braque pioneered paper collage techniques. In the 1950s, Jackson Pollack used aluminum house paint, while Robert Rauschenberg and Frank Stella incorporated surprising and sometimes outrageous three-dimensional items.

It's not unusual for artists today to use all sorts of found objects. There's also a strong trend toward experimental techniques with acrylics, ingenuity in printmaking, and the use of creative substrates for paintings.

This section has ideas to jumpstart new directions in your artwork.

144 A CERTAIN SURFACE

Create a bas-relief by gluing small items—such as nuts and bolts, buttons, twigs, scraps of wood, small boxes, and plastic letters from kids' reading sets—to a rigid surface. Wood or Masonite™ panels work well.

Use acrylic paint to coat the entire surface with one color to unify it. White and pale colors allow light and shadow to show on your surface. This piece makes a great base for further development, such as adding color accents from paint, collage, or more attachments.

145 ART THAT STICKS 1

Use a series of two-by-four pieces of lumber as canvases. Paint and arrange the "sticks" to hang individually or in a grouping, either vertically or horizontally. The edges can be painted in solid colors or in other interesting ways. Wood holds acrylics, oils, inks, and egg tempera beautifully. Apply gesso first, or seal the wood with clear acrylic so it is not overly porous. Oil or acrylic paints can be applied over the clear acrylic. These make great substrates for collages.

Because of their shape, the two-by-fours take on a wonderful look painted in abstract, primitive, or folk art styles. Consider creating painted totem poles that display symbolic faces.

SEE RELATED IDEA 163, "ART THAT STICKS 2," ON PAGE 103

146 THROW ME A CURVE

Cut or tear papers in curved edges only. Layer, weave, and intertwine them for some interesting organic collage effects. Explore curves in painted compositions, using mainly swirly, lyrical, curved lines to express a vision. In contrast to Cubism, try Curve-ism.

147 TRASH ART IS NOT GARBAGE

From small found objects, broken pottery, and crushed cans to junkyard cars, contemporary artists are making beautiful statements from recycled trash, often referred to as upcycled art. By changing the use of familiar items, trash artists encourage us to rethink the meaning of the things we consume and discard.

Separate from a piece of trash's intended use, it has attributes, which refers to the visual and tactile qualities that artists can use as elements of design. Every piece of garbage, be it a gum wrapper or an old shoe, has colors, a shape, and a texture.

It is made of something that can be altered by cutting, twisting, or crushing. Pieces of garbage are "paints" from which a trash artist develops artwork.

American trash artist Tom Deininger (contemporary) is one of the most creative painters in the world. When viewed from a distance, his gorgeous landscapes appear to be impressionistic oil paintings. A closer look reveals computer keys, plastic toys, and bits of discarded packaging covering a canvas.

American trash artist Elizabeth Lundberg Morisette (contemporary) gathers objects of one kind and repurposes them into artwork that is sometimes a serious statement and sometimes just for fun. She created an amazing collage from PEZ™ dispensers and a series of bas-reliefs from old zippers. Golf tees, plastic beads, and milk-bottle rings are her favorite art materials. The visual rhythm she develops by applying multiples of like items to a surface is lively and beautiful.

If you enjoy creating with mixed media, scavenge for old trash and new materials to inspire your next artwork as you literally turn trash into treasure.

Bonus: Here's an art form where art supplies are free!

148 ALCOVE CANVASES

Cut an alcove into your canvas to fill in with painted or collage elements or to place three-dimensional icons inside.

Start

+ Place an 8-inch by 10-inch or larger stretched and primed canvas facedown, stretcher bars facing up.

+ Position a smaller canvas, such as a mini-canvas (4-inch by 6-inch or less), within the larger canvas's stretcher bars, front canvas surface facing up.

 Note: The depth of the small canvas should be the same or less than the depth of the large canvas.

Position It

+ Grasping your small canvas in place, hold the large canvas up to the light so you can view the position of the small canvas within it. You'll see where your alcove will be—the space within the small stretcher bars.

+ Trace the shape of the opening onto the front surface of the large canvas.

Adhere It

✦ Lay the large canvas facedown, keeping the small canvas in its position. Use heavy acrylic gel or an acid-free adherent on the back surface of the small stretcher bars and the back canvas area they cover. Put some weight on the small canvas and allow to dry fully.

Cut the Opening

✦ Using a razor knife, cut an X from corner to corner of your alcove shape in the front canvas.

✦ Fold the flaps down into the alcove, and secure them in place with acrylic gel.

✦ Option: Cut around the opening, leaving no flaps.

Finishing

✦ Smooth the alcove surfaces and edges with gel, gesso, or paint. Let dry, then add your artistry.

149 SHAPE-UP

Try an unusual shape, such as a narrow vertical canvas, an arched top surface, a traditional wood palette, a triangular shape, or a circular shape. These can also be glued onto a traditional rectangular or square canvas.

150 INSIDE-OUT PAINTING

Painting on the back of a stretched canvas will give you a shadowbox effect, into which you can add objects. Unpainted stretcher bars look avant-garde and deconstructivist. To enhance the effect, fray the edges of the canvas that wraps around toward the back. Paint or collage the stretcher bars for a more refined, fully designed look.

Tip: To paint on the back of a stretched canvas, gesso the back surface first, then apply paint or collage elements.

For another approach, use the backs of miniature stretched canvases in multiples. Coat a larger canvas with acrylics. Then adhere the front surfaces of mini-canvases to your larger canvas with acrylic gel. Add paint and collage elements to the small exposed stretcher bars and in the tiny shadowbox alcoves.

151 TINY CANVAS COMPS

Miniature paintings are ideal for exploring light and dark compositional patterns and for developing final comps for larger paintings. Comps that you normally would sketch on paper can be done on tiny canvases, with the added by-product of an original work to exhibit or sell.

152 DRIPS ARE NOT DRAB

Do a painting about the attributes of paint. Showcase paint doing what paint does; it drips, splatters, puddles, swirls, and smears. Acrylic paint is a good choice for these techniques.

Paint a solid color on a bas-relief of items glued to a board and let it dry. Then cover the piece with "uncontrolled" paint in several colors.

Explore this technique on a canvas. The canvas can be pre-painted a solid color or in multicolored brushstrokes to serve as an underpainting. Old, unsuccessful paintings make great underpaintings too. Finally, unify your piece as an abstract composition.

Paint Imaging

Follow the above description while painting on a canvas, letting the paint do whatever it does. Then find representational imagery within your organic paint "happenings." Look for creatures, angels, weird spirits, acrobats, dancers, trees, flowers, houses, ships, skies, planets, galaxies, unknown beings, and whatever else an unleashed imagination conjures up.

Bring that imagery into focus by defining and refining it in painted detail. Let flowing paint areas morph into representational subject matter, then dissolve again into swirls of color.

SEE RELATED IDEA 84, "HIDDEN FACES," ON PAGE 70

153 A BIG NATURAL BEAUTY

Collect gorgeous autumn leaves, and scan or photocopy them in color at 200 percent to 500 percent or more. You'll be amazed at the beautiful structures and surface variations that are revealed! These are inspiring sources of abstract ideas. Isolate parts of your enlarged leaf to find exciting compositions. When it comes to color harmony and exquisite texture, nobody does it better than Mother Nature.

Other natural beauties to enlarge and observe include flowers, plants, butterfly wings (but never kill live butterflies), pieces of wood grain, flat pebbles, and twigs. Try fake flowers too.

154 BIGGER THAN LIFE

If you love imagery, you probably collect magazine and newspaper clippings, online printouts, textile and wallpaper fragments, pieces of lace, scraps of ephemera, bits of torn loveliness, and eye-catching junk mail. Perhaps you make pencil or crayon rubbings from kids' textured templates or from found objects with distinct textures. This technique is called frottage. These rubbings can become the beginnings of abstract paintings.

Enlarge your imagery 200 percent to 600 percent or more, depending on the image and the capability of the copier. Black-and-white often works just as well as color for this concept. Huge magnifications reveal amazing abstract shapes and textures. This special reference is ready for your interpretation on canvas.

155 TURNED-ON ART

Place your canvas on a lazy Susan or any turntable you can control with your hand. Experiment to get some great swirly effects in acrylics, oils, or watercolors. Try various brush types and brush motions as you turn your canvas. Add turntable effects at any stage of your painting, or do an entire painting in this manner. As always, your painting must have color harmony and good composition to showcase interesting brushwork and paint applications.

156 BUTTERY BEAUTY

Create an acrylic or oil painting on canvas with palette knives and other tools for applying paint, such as old credit cards, kitchen utensils, and discarded packaging materials. Butter the paint on thickly; the texture of paint itself is beautiful. Scrape through it; use short staccato motions, dabs, or jabs; or spread the paint with sweeping motions.

There is no "right" technique. Use whatever applies pigments in the way that achieves the look you are after. That will be the right technique for you.

Explore the shapes and performance of various palette knives. Use the sides of each palette knife as well as its flat surface. Experiment with many improvised tools.

157 WHAT'S-IT BRUSHES

Complete an entire painting with nontraditional items repurposed as brushes. Acrylics and watercolors on canvas or heavy paper are easy to use, but any materials can work. Dip your "brushes" into paint and apply them to the surface.

Small rolling pins, leafy branches, pieces of cardboard, extruders, squirt bottles, mops, feather dusters, and bunches of rubber bands will surprise you, loosen you up, and unleash your imagination right onto your canvas.

Make your own brushes by pulling the foam off cheap foam brushes and gluing on other things, such as strips of fabric or whatever will hold paint and make a unique mark.

158 DIGIT-ISM

Do a finger painting in oil painting while wearing latex gloves. When it comes to tools for applying and manipulating paint, nothing will be as sensitive to pressure as the digits you were born with.

Work on a smooth, thoroughly dry canvas underpainting. The paint you apply with your fingers will move around more easily over a pre-painted surface. Solid colors or multicolors softly blended together work best for your underpainting, but you can make any style work.

"*I*T'S ON THE STRENGTH OF observation and reflection that one finds a way. So we must dig and delve unceasingly."

—CLAUDE MONET

CHAPTER 10

The Serious Series

One characteristic that often separates professional artists from amateurs is their enthusiasm for creating several works of art around a single theme.

I've found that gallery owners prefer to represent an artist with several related works rather than an artist who presents a variety of mediums, styles, and subject matter. Creating artwork in a series is the easiest way to acquire an artistic identity in the minds of viewers.

If you are an eclectic artist who loves it all, as do many artists, create more than one series of artwork. Develop a series, then develop another. Or allow your artwork to evolve into a new series. It's okay to be a "serial series" artist as well as a single series artist.

Twenty Serious Series Reasons

The reason an artist develops a specific series will of course vary with each artist. Here is a sampling of some motivations:

1 Explore a certain motif
2 Explore an idea or concept

3 Explore an object as subject matter

4 Explore design factors

5 Explore the effects of color

6 Explore textures

7 Explore the dynamics of composition

8 Explore the look of brushstrokes

9 Explore one's subconscious

10 Explore the unknown

11 Fulfill a wish

12 Honor someone or something

13 Indulge in a passion

14 Portray a fantasy

15 Record history

16 Record nature

17 Release an emotion

18 Reveal a spiritual experience

19 Reveal insights

20 Tell a story

If any of these motivations resonate with you, you may have discovered the basis for your next series of artwork. Or maybe you have another inspiration. Such focus can deepen your growth as an artist.

159 ARTFUL INCHES

Create a series of small works on paper, card, or mini-canvases in any style. Approximately four inches or less in any direction works well. Paint or collage a large canvas, and use it as a background for mounting several small compositions together. If they have uniform size, mounting a series of one-of-a-kind compositions onto a large surface results in a beautiful juxtaposition of repetition and variety. For further unity of the smaller elements with each other and the background, consider painting across all the mounted pieces with a harmonizing color. Do not cover up too much of your original elements.

160 COMMON COLOR COMMENT

I know an artist who honors her favorite color, burgundy, by creating dozens of miniatures using that color in patterns. She uses burgundy as a dominant element in several compositions and as an accent color in others. The common denominator is the color. She mounts her miniatures in groups on large canvases, making statements about the visual effects of that particular hue.

161 DOUBLES AND TRIPLES

Create paintings in pairs, called diptychs, or threes, called triptychs. The challenge is to have them make a general statement together and hold up individually. Develop two or three paintings simultaneously to maintain color harmony and consistency of style. Developing companion images for paintings boosts the visual impact for them all.

162 THREE GREAT WAYS

There are three main approaches to composing multiples:

1 Create one scene that continues across two or three canvases.

2 Create a series of individual compositions with a common look and theme.

3 Develop a major center of interest in one canvas only, and keep the additional canvases subordinate to that piece.

163 ART THAT STICKS 2

Paint several two-by-four lengths of lumber and arrange them as triptychs or more to hang in multiples, either vertically or horizontally. Cover an entire wall area with a series of these to create the feeling of a large piece. Graduated solid colors create a color field feeling. Try painting the edges a contrasting color, which will show more or less depending on the viewer's vantage point.

SEE RELATED IDEA 145, "ART THAT STICKS 1," ON PAGE 94

164 PUSHING THE SMALL ENVELOPE

Use small works as outrageously as you please, pushing the avant-garde envelope. I've seen artists depict shocking concepts, make outrageous art statements, do the unacceptable, apply wildly discordant colors, and intentionally break the compositional rules along with the unwritten rules of good taste. Going outside the bounds feels emotionally safer when the bounds

are only a few inches in any direction. Pushing a small envelope helps you stretch your artistic limits and encounter the universe from unlikely perspectives. Unleash your artistic impulses, a little bit at a time.

165 A SERIES OF SERIES

Working within 4-inch boundaries lets you explore ideas for a series quickly, in just a few hours rather than weeks. Think of miniature artworks as comps for a series rather than comps for a single painting. Experiment with the looks of more than one distinct series to find what has the best impact in multiples. Then translate your favorite mini-series into a series of larger canvases.

166 GETTING AROUND WITH A "LITTLE"

Find a small object that appeals to you, carry it with you wherever you go, and sketch or photograph it in different settings. An artist friend photographs her toy tortoise everywhere she goes. The replica reptile poses on windowsills in restaurants, shows up in Canada, and appears on a grocery-store shelf alongside the soup cans. A collection of photos such as these could become reference for a series of paintings. The message? Perhaps something about "slow and steady gets around." Another artist I know photographs a spike-heeled shoe everywhere she goes. Her message? Perhaps something about "slow and sexy gets around."

167 THE SERIOUS SERIES ON CANVAS

Try a Little Technique: Working in miniature lets you experiment with media and practice techniques to your heart's content. Try new styles, knowing you can complete an artwork quickly. Repeat a new technique often to gain proficiency. Try new materials and try expressing unfamiliar interpretations of what you see. Use mini-canvases as a way to broaden your artistic skills and increase your creative output.

Four Square Seasons: Paint the same scene on each of four square canvases, with each canvas showing a different season. For example, show an apple tree bearing fruit in the summer, show the changing colors in the autumn, show branches covered in snow in the winter, and show blossoms in the spring. Hang the paintings as a group horizontally, vertically, or two above and two below.

Be a Square Series: Square-shaped surfaces have their advantages. They can be painted as a series to hang together, with the ability to fill wall space as needed:

vertically, horizontally, double rows, and four creating a larger square. Adjust the space between them.

The visual impact of paintings in a series is exciting. Ideally, each piece should hold up on its own, with each piece strengthening the effect of the others.

Tips: To create a successful series, establish a common denominator that occurs in each painting. The common denominator can be a color scheme, a group of shapes, or variations on a theme, such as dogs, hearts, letters, and abstract brushstrokes. There must be unity among the pieces as well as varieties.

An alternative approach is to assemble your painted squares flush with each other, quilt-style. Consider using canvases of varying edge depth, so that some of the pieces in your "quilt" will protrude forward more than others. This adds interest to the surface of your piece.

Squares of gallery-wrapped canvases and wood panels are easily available, and they don't need framing. This is an important economic consideration for work that will be displayed in multiples.

SEE RELATED IDEA 11, "TIS THE SEASONS," ON PAGE 39.

"Every artist
dips his brush in his own soul,
and paints his own nature
into his pictures."

—HENRY WARD BEECHER

CHAPTER 11

Developing a Signature Style

Most artists wish to develop a distinctive look that sets their work apart. Your signature style is that special quality that makes your drawings and paintings uniquely yours and no one else's.

Like handwriting, every artist's touch with a brush is their own. We each have personal color and composition preferences. As individuals, our visual statements and artistic interpretations are ours alone.

Skill Leads to Style

Look for unique and even quirky qualities that naturally occur in your art. Decide if you want to emphasize or minimize them. Trust your natural ways, but also know that the more skills you acquire as an artist, the more your instinctive style can emerge. Skills empower you to express what you have to say and what you want to show.

Ordinary Subjects: Extraordinary Art

No matter how many millions of vases of flowers, trees by the lake, or children on the beach have been painted by other artists, *you*—being

the individual you are—can bring something new and compelling to a familiar subject. It's always a mark of distinction to paint a popular theme when you truly love your subject and you paint it *your* way.

168 TECHNIQUE VERSUS STYLE

Technique: Technique refers to the manner in which paint is applied to the substrate. Some artists consciously apply surface techniques to their paintings. This often produces interesting pieces. But techniques for their own sake, however appealing they look, are not examples of true style; they are examples of decorative effects. The conscious effort to produce a specific look will not have artistic authenticity unless you use that technique to explore something deeper. But remember, art has no rules that are always true.

Here are two great masters whose work is often referred to as decorative—yet their paintings are so beautiful, they rise to the highest level.

✦ **Alphonse Mucha** (1860–1939) was a Czech Art Nouveau painter known for his posters and illustrations of beautiful women surrounded by flowing floral borders and elements. His work is often referenced by contemporary designers.

✦ **Gustav Klimt** (1862–1918) was an Austrian Symbolist painter known for his paintings of women and landscapes embellished with gold leafing, Byzantine patterns, and real gemstones. His work is still beloved today.

Style: If you choose a way to apply paint because it helps you express your ideas, then it is true style. Or if your technique is a result of your natural expression, such as dots and dabs of paint as you strive to capture reflections of light, this is also true style.

Developing True Style: True style emerges through your observation, interpretation, artistic choices, and handling of materials. It flows out of your genuine effort to create art. Your artistic style will evolve throughout your creative career as you continue to grow and change as an artist. The key word is "authenticity."

Style Is Separate from Subject Matter: Any subject can be painted in any style. However, selecting a specific subject to explore often leads to style as you seek the best way to depict it.

169 IDEAS THAT DEVELOP STYLE

Animal Specialist: If you have an affinity for a particular kind of animal, become an expert painter of the species. Study its anatomy, features, colors, textures, and body language. Learn about its natural environment, behavior, and biology. Get to know your living subject in as much depth as possible.

Sketch it over and over again, preferably from life. Repetition is the key to knowing your subject and painting it well.

The art world abounds with artists who paint cats, dogs, owls, and horses. If you love them, by all means paint them, but try to bring a fresh interpretation to your portrayals.

It may be more rewarding to select a creature that is not so often the subject of art. Show the world the wonders of elephants, frogs, kangaroos, starfish, armadillos, flamingos, sloths, or water buffalo. If you don't have a compelling animal in mind, go to the zoo and see if you make a connection with any creature.

A lot of people collect particular animal motifs because of their symbolic significance. Often you'll attract a niche following of others who also love your creature.

170 THAT SOMETHING SPECIAL

Become an expert painter of whatever subject matter speaks to you, however odd or humble. Anything and everything is worthy of an artist's touch. Whatever you are moved to paint is a superb choice.

Just by selecting a subject, you elevate it to an important status. As an artist, your task is to show others an extraordinary aspect of something they might not have noticed on their own.

Another Kind of "Impressionist": I once knew an artist named Donna who painted overstuffed chairs. She developed this passion in art school. Bored with figure painting, one day she was spellbound by the impression a model left on a chair when she took a break. From that day forward, she painted chairs with the haunting impressions of those who had sat on them.

Lions and Tigers and Pears, Oh My: Successful artists have specialized in portraying weird skies, gooey desserts, old buildings, wine bottles, stone walls, tulips, cups of coffee, alphabet letters, scuffed sneakers, children playing, sports

scenes, doorways, weathered wood, ballerinas, unidentified flying objects, locomotives, aprons, toys, fishing tackle, antique valentines, vintage machines, storefronts, baskets of fruit, ancient saints, cowboy gear, dragons, historical portraits, lizards, gemstones, and windmills.

As a specialist artist, you're likely to attract a niche following of others who have an affinity for your subject matter.

171 INTERPRET A PASSION

If there's a subject you're passionate about, paint it *your* way. Experiment with media, color, and composition, but most of all, emphasize your instinctive style. Never alter your unique way of seeing to fit someone else's notion of how they think a subject should look. Paint your subject over and over again, indulging in your passion. Magic will happen.

A Rose on Bold Bloom: If you see simple bold shapes in things, and you happen to be passionate about roses (which are commonly depicted softly), your way of seeing can bring a jolt of the unexpected to your subject. Boldly painted roses are your natural expression because you love roses and your visual interpretations are bold.

You can give viewers a new experience with roses. Next time they stop to smell the roses perhaps they'll think of bold new paintings.

SEE RELATED IDEA 128, "A ROSE IS A ROSE IS AN ABSTRACT BEAUTY," ON PAGE 86

Sailboats in a Paisley Sea: My friend Jack loves sailing. He retired from a career as a textile designer, but his passion for pattern never faded. He sees patterns everywhere—more distinctly than others usually notice. Jack paints his great passions: sailboats on patterned waters under repetitious clouds in the sky. His emphasis on the repeated patterns he perceives turns his watercolors into wonderful nautical depictions that are totally unique.

Making Walls and Breaking Some Down: I went to school with an artist named Brad. His passion for painting crumbling brick walls was obvious in his "wall" series. He thoroughly enjoyed the experience of painting intricate details, giving each brick its own personality. He apparently loved subtle color and texture, since he covered canvases with these elements, creating special tactile experiences for the viewer. Brad's brick-wall paintings broke through traditional ideas of what a composition "should" be.

172 CUSTOM COMBO

One way to invent a style that's distinctively yours is to combine the styles of two masters that you love. If you love Claude Monet (1840–1926) and Jasper Johns (contemporary), experiment by using the color palette of one master with the brushstrokes of the other. Or wed both methods of paint application in one painting. The merger possibilities are infinite.

173 ISM-ISMS

A delightful way to explore developing a new art style is to combine two style "-isms" from art history. For example, join Cubism with Pointillism to create a look that employs the rearranged perspective of cubism rendered in dots for optical color.

174 UNIQUE-ISM

Invent your own "-isms." Try square-ism, stripe-ism, swirl-ism, drip-ism, spatter-ism, lost-edge-ism, hard-edge-ism, elongate-ism, pink-ism, rainbow-ism, curve-ism, broken-line-ism, dot-ism, dash-ism, jagged-ism, triangle-ism, black-ism, repetition-ism, or fog-ism. Meld together two of your own -isms. The results might be amaze-ism.

175 ICONOLOGY

The history of art is rich with visual symbolism. Make a list of icons, or visual symbols, that are meaningful in your life. Dictionaries of mythology, folklore, and symbols are treasure troves of icon ideas. Create a personal list to use as reference for incorporating symbolic messages into your artwork.

The yin-yang, the ankh, and the heart are abstracted symbols. Animals, flowers, numbers, mythological imagery, and colors have symbolic meanings, which vary from culture to culture. Research the origin of symbols you like.

Design your own set of icons. Create symbols that are meaningful to you, such as a butterfly representing hope or a triangle representing stability. Develop a unified look for your symbols, and use the iconography to tell stories.

176 ANCIENT INSPIRATIONS

Copy an ancient art look, but change the "color story" by using a new color palette. You will achieve a distinctive new style.

177 OUTSIDER ART

The term "outsider art" was coined by an art critic in the 1970s as a synonym for "raw art." The term was used to describe art created outside the boundaries of a mainstream art community. In many cases, outsider art could be described as "urban folk art."

Outsider art originally portrayed extreme mental states, outrageous ideas, or elaborate fantasy worlds. In recent years, the term has become a marketing label for art created purely for personal expression without concern for others' opinions. The growing trend has now spawned outsider art fairs.

Outsider artists often use odd materials and unconventional subject matter. Artwork ranges from the naïve and primitive to the urban funky and irreverent to the visionary and eccentric—and everything else that defies categorization.

The next time you have a wacky notion, don't disregard it; make it visual. As an artist, it's essential to be free. Creating outsider artwork is a way to get in touch with your intuitive art spirit.

178 OUT-SIZER ART

When you paint a very large picture, emotionally you are "in" it. You are likely to feel small and human when gazing at an oversized painting. The colors become your environment, and the composition becomes an experience. Nonobjective and abstract paintings often need to be large to make a statement. For example, color field paintings, which create an experience through a color, need to be large to deliver their message.

When a viewer feels he or she is small and inside a painting, it is a very different experience from feeling large while looking at a small reproduction of the same painting. It's an enlightening experience for an artist to paint an oversized canvas once in a while.

179 VISUAL METAPHORS

A visual metaphor is the use of images rather than words to make a comparison. The history of art is rich with visual metaphors. Surrealist painter Salvador Dalí (1904–1989) often painted melting clocks to represent eternity.

Every artist has their own language of metaphors. Make a list of metaphors as you perceive them in your life, and use them to express your visual narrative. A circle may symbolize harmony and inclusiveness to you. A plant may symbolize life, and a cloud may symbolize imagination. Colors also have symbolic associations. Incorporate your personal metaphorical imagery into your compositions to help make your statements uniquely yours.

180 ALPHABETICAL ORDER

Research ancient and primitive alphabets, hieroglyphs, and letter forms around the world. They are beautiful designs in their own right, as well as having literal or symbolic meaning. Pages of text, including handwritten passages, make appealing textures for collages and interesting background surfaces for drawings and paintings. Try incising lettering into acrylic modeling paste. There are infinite ways to develop a personal art statement through letter forms.

SEE RELATED IDEA 130, "A WORD ABOUT ART," ON PAGE 87

181 A STAMP OF DISTINCTION

Have custom rubber stamps made with your own exclusive words, symbols, and messages. Add intriguing meaning and surrealistic effects to your work through words and messages.

182 EXPERIMENTAL EXERCISE

Select an image from your picture references (see Chapter 4) that has a quality that you would enjoy painting. Is there something in the color combination, the styling, the lighting, or the composition that appeals to you? Do a quick painting inspired by that image, but avoid copying it. Don't worry about outcome; just immerse yourself in the experience. Doing an exercise like this can fine-tune your preferences.

"*H*AVE THE COURAGE
to follow your heart and intuition.
They somehow already know what
you truly want to become. **"**

—STEVE JOBS

CHAPTER 12

Painterly Advice

There's an art to being an artist. It has to do with attitudes and habits that keep your creativity flowing, that support your expressive endeavors, and that help you believe in yourself. Consider the following ideas, and if they speak truth to you, take them to heart and art.

183 THE TWO COMMANDMENTS OF ART

Paint What You Love: Don't think about what might sell or become influenced by what friends, family, and other artists like. What others prefer is right for them, but there's no point in being an artist unless you portray your unique visions. Paint only what *you* love.

Paint the Way You Love to Paint: How you love to paint isn't the same as the paintings you love to look at. I adore the works of accomplished *plein air* artists but I don't enjoy painting outdoors. Nor do I feel a deep enough connection to the subject matter to sustain my interest. Although I admire *plein air* paintings, pursuing this path as an artist is not right for me.

The way I love to paint is comfortably in my studio, in pajamas day or night, experimenting with bits of colors, textures, and detailed patterns. I love to paint the human figure. Sometimes I combine these themes. But I have no plans to paint landscapes on location, in my pajamas or not.

184 MAY THE CREATIVE FOURS BE WITH YOU

As you work, keep in mind that successful paintings are a medley of four things:

+ Interesting subject matter
+ Solid drawing skills
+ Mastery of materials
+ Personal expression

185 WHAT MAKES A SUBJECT WORTHY?

The subjects you paint don't have to be profound statements about life and the universe. Don't be intimidated by lofty expectations from the art world. If whatever you have to say is sincere, it's worthy. Painting is sensual, visual, and emotional. Maybe you're just saying "look how much I enjoy painting." That's a valid reason to paint.

After I graduated from college with a major in fine art, I was stymied because I didn't think I had anything important to say in art. The subject matter I loved didn't seem important enough to paint. I wasn't alone; many of my artist colleagues grappled with similar self-doubts. One day I said, *I'm going to paint anyway, because I love the feel of the creamy paint and I want to see what colors and shapes do on a canvas.* I haven't stopped painting since—and I know my works are worthy because they're authentic.

186 OWN YOUR REALITY

See your canvas as the reality, and not the scenery, model, or still-life setup. Don't paint what you see; paint how you want your canvas to look. Use the "real" world as reference for you to interpret, not to copy. Don't paint what you see, but rather, see what you paint.

187 IN PRAISE OF UGLY PAINTINGS

Keep unsuccessful paintings to use for warm-ups. You'll relax and work intuitively, and you won't worry about ruining a bad painting. Try to find something good in the bad that you can highlight for a new focus, or simply use the "uglies" as bases for experimentation. Uglies make great foundations for paintings, because the underlying colors and textures add richness to your new, repainted surface. Ugly paintings have history; they're old souls. Some of my most successful paintings were built upon bad underpaintings.

188 IN PRAISE OF BAD PAPER

Every art student I've known has experienced this phenomenon: When they used the fine, costly-per-sheet paper, their drawings came out stiff and uninspired. Most likely the artists were inhibited by worrying about ruining the paper. My best drawings were always done (inadvertently) on cheap, crummy paper because I was relaxed and worked with abandon, letting my creative juices flow.

I'm not sure how to solve this problem, other than accepting the reality that you may lose your investment in the paper if your drawing turns out poorly. Then go ahead and try to work with abandon anyway. If possible, have an extra sheet or two on hand for beginning again. Knowing you have a second chance might help you relax.

It's reassuring to have a Plan B. Work over a bad drawing or painting with experimental techniques or consider using elements of it for a collage.

Work on inexpensive paper if you feel more comfortable, but research ways to protect and preserve your artwork on such paper. Spray varnishes, glazes, and mounting it on a more durable substrate are options to explore.

189 BRUSH-OFF

I once had an art instructor who would repeat, "Don't get married to your brush. Change brushes for different areas of your painting."

To this I add, "Experiment with several shapes of brushes." You may find that an unfamiliar brush style will become a favorite after you try it. A great brush can help you advance your expression.

190 MEDIA SWITCH

Add a jolt of new awareness to your visions by changing the type of materials you use. Switching from oil to watercolor can make a dramatic difference in how you see and express what you see. It's worth trying even if you revert back to your familiar medium.

191 ABSTRACT INCOGNITO

An important quality that can make your abstract or nonobjective painting distinctive and intriguing is a sense of mystery about your methods. Disguise how you did it. If your technique is obvious, the piece may lose some appeal.

Camouflage your technique by layering, glazing, using a variety of brushstrokes, applying unusual textures, customizing your paint, and finding new ways. Experiment to find what works best for you. Stretch your imagination to create aesthetic illusions that will leave your viewers wondering how they were done. First and foremost, you must build upon good composition and color harmony. Without those two requirements, techniques are meaningless.

192 FEELING YOUR WAY

Surrender your next painting to your love of color and the sensual feel of the paint. Cover your canvas with colors, letting your feelings be your guide. Whether you use acrylics, oils, or watercolors, put a sheet of clear plastic wrap over your wet surface and burnish it with your hands. The paint will spread and ooze across your surface. Remove the wrap, and continue feeling your way until your expression feels complete. Whatever you do will be yours alone, and as a contemporary artist, your painting has meaning in the world.

193 WRITING ABSTRACTS

As soon as you come up with a concept for an abstract or nonobjective painting, write it down so you don't forget your intention. Spend a couple of minutes writing about how your painting should look to convey your idea or emotion. Put your writing away, but keep it close at hand.

Begin your painting, letting your intuition be your guide. If you feel you are led astray and losing sight of your goal, refer back to your writing and correct your steps. Your written declaration of your intention will guide you through to completion.

194 THE UN-RENAISSANCE-ISTS

We often feel we should master every medium and be accomplished artists with all subject matter. We feel diminished if we're less than masterful with human anatomy, making powerfully dynamic compositions, or our handling of watercolors.

The best artists I know have drawing skills and an understanding of color and composition. Beyond that, they tend to stay with one subject area and a medium that works for them. Don't try to be a jack-of-all-art, master of none. Do what you love best, and your talent will shine.

195 MASTER THE MEDIUM

Select one medium that you enjoy, and practice mastering it. Gain expertise by learning how that medium responds to your brushstrokes and becoming familiar with its color range. Experiment endlessly, learning everything your medium will and will not do. Study the work of great artists who have used that medium, and find your personal best way to use it.

The more mastery you have over your medium, the less you'll struggle with technical issues—and the more your creativity can flow smoothly and unhindered by "material" difficulties.

196 TELL A STORY

Creating artwork that gets positive viewer response depends not only on the execution of your idea but also the power of the idea.

To tell a story in a representational painting, first determine your idea. It can be a simple idea, like a peaceful beach whose story is your longing to be there, or a tender plant poking through some melting snow whose story is the arrival of spring.

Perhaps your story showcases nostalgic items. Maybe it exposes society's injustices, or it might be a visual story about the textures of trees. The possibilities are infinite.

Write down your story idea, and keep it where you can see it as you paint. Hang the words on your easel, or tape them to the wall. Eliminate everything in your painting that's not essential to that idea. By staying focused on the story you wish to tell, your painting will be an effective statement.

Viewers enjoy paintings when they derive meaning from them. A series of paintings with a common storyline will highlight your statements all the more.

197 CREATIVE CONNECTIONS

Artistic creativity requires the ability to make connections between unrelated things. This includes forming metaphors and seeing analogies. It involves using your imagination to find associations between dissimilar things. Visual metaphors add power to your paintings.

Marshall Vandruff, an accomplished artist, top freelance illustrator, and art instructor in Southern California, tells his students an important secret about creativity: "Creative people play with metaphors. They look at one thing as if it were another thing. For instance, look at every person as if they were an animal. Think of how your idea is similar to another idea. Ask, 'What other thing can I

say my idea is like?' For example, an idea for a painting of a dragon could be like the image of a spiraling tornado. An abstract painting could be like a cityscape.

The French painter Georges Seurat (1859–1891) made another kind of creative connection in the late 1800s. As Seurat gazed at a green field dotted with yellow wildflowers, he observed that the field looked solid yellow-green. Yellow-green was the exact color that would result by mixing the dark green color of the field plants with the yellow color of the wildflowers.

Seurat speculated that if the eye can mix the separate colors of nature in a large field, why couldn't it mix separate colors of paint on a canvas? Seurat experimented with dots and dashes of paint, and he introduced Pointillism to the world. Seurat made a creative connection between a field of flowers and dots of paint on a canvas.

SEE RELATED IDEA 119, "DOT YOUR EYES," ON PAGE 82

198 CREATING BY DOING

Just the physical act of creating—of applying paint to canvas, dragging a pencil across a surface, or fashioning something tangible from raw materials—will get your creative juices flowing. Rather than needing an idea first, start the physical motion of making art. As you relax and enjoy the activity, inspiration and ideas will follow. Sometimes creativity is simply about the *doing* of art, and creativity emerges through who you are, how you interpret what you see, and how you see as you create.

Warm-ups: Keep one or two unfinished warm-ups in your workspace at all times. A warm-up is a painting you work on just for fun. Because the paintings are free from expectations, they'll ease you into a relaxed, creative state of mind. Warm-up paintings let you de-stress and be productive at the same time.

199 PLAY WITH YOUR CREATIVE BLOCKS

If you are frustrated with a painting or are experiencing a creative block, put your work aside and forget about being productive. Just have fun with your art materials, playing with brushstrokes, colors, and techniques. Enjoy the process without any concern about finished products.

The fun parts of art will hearten you and get your creative juices flowing. It could take an hour, a day, or a month, but your creativity will start to flow again.

200 A PLAY DATE WITH OTHER ARTISTS

Creativity is contagious. Arrange a time and place to "play" with other artists, sharing artistic explorations. You'll inspire and learn from each other. Just by working together, new perspectives will flow through your mind. Often a new point of view will knock down a creative block.

I belong to an "experimental artists group," which meets once a month. We take turns introducing each other to techniques, materials, and concepts for making art. The group has become a valuable part of my professional life, keeping me enriched by others' interpretations, expressions, passions, knowledge, and experiences. Start a group if there isn't one in your area. Ten to twenty members is ideal, but even two creative souls can benefit each other.

Visit galleries and museums with artist friends. If you don't know any other artists, sign up for an art workshop or join a local art organization. If you have kids in your life, you can enjoy viewing and making art with them.

201 A PLAY DATE WITH YOUR PAINT

Put aside a few hours every week to slosh around with your materials, practicing skills, experimenting, loosening up, playing with ideas, and exploring new techniques. Make notes in your journal about these experiences. Take this playtime seriously. It will keep you artistically fit.

202 ALWAYS KEEP A JOURNAL AND PEN WITH YOU

You never know when a great idea or amazing inspiration might come your way. Capture it before it disappears, as ideas are prone to do. One of those ideas could be the forerunner of a magnificent body of work. Your journal is a precious companion. Keep it close at hand.

SEE CHAPTER 3, "YOUR ART JOURNAL: KEEPER OF INSPIRATION," ON PAGE 23 FOR MORE DETAILS

203 DO SOME ARTWORK EVERY DAY

Spending even ten minutes a day sketching or painting will significantly boost your skills. Practice your ability to get your ideas down, hone your drawing skills, sharpen your observation skills, and exercise your visual imagination. With just ten minutes a day, you will have acquired much proficiency in a year. The important thing is to be consistent and stay in touch with your creativity.

204 NEVER STOP LEARNING

Read books about art and artists, and visit galleries, museums, demos, and artists' presentations. Read about their artwork, work habits, and beliefs. Check out art blogs and other artists' works online and read their statements. Talk to other artists about their motivations, inspirations, methods, and ideas. Our greatest inspirations come from those who are greatly inspired.

Take classes and workshops. Try new materials. Never stop learning, mastering your tools, and building your skills. Being an artist is a lifetime commitment. Even if you can't always make art, you can always learn something new.

205 TAKE RISKS WITH YOUR ART

Apply your favorite ideas, however wild, and explore new materials, however unusual. Try outrageous notions. Don't be afraid to do an ugly painting or a failed experiment. Every great artist has been there. There's something to be learned from every unsuccessful artwork. Failures are meaningful steppingstones on your path toward artistic growth.

206 CREATE STUDIO SPACE

Whether you claim a corner of a room or build a gorgeous studio, you need regular space to work with good lighting, supplies handy, and quiet moments. Your space must be sacrosanct. Establish a routine and, unless it's a dire emergency, don't let anything or anyone interrupt your art time.

207 TAP THE POWER OF IMAGINATION

Exercise your creative wings and let your imagination soar. Travel the hidden lands in your mind that only you can see. Shrink yourself until the center of a flower becomes a wide-open space, and be a *plein air* painter there. View the world from the vantage point of the Milky Way. Face your deepest emotions and see what they look like. Visualize your spirituality. With creative thought, you'll see things from unique and amazing points of view. Let those visions appear in your artwork.

208 HAVE FUN

Creativity is optimistic. It starts with the unknown and believes in finding answers. It starts with a vision and believes in an artwork. Having fun makes you feel optimistic, opening your mind for creative thoughts to flow through. Paint what pleases you in a way that feels good. Regardless of your message, let making art be a joyful experience.

209 SIGNING YOUR ARTWORK

Sign your name in the lower right corner of your painting, leaving enough of a margin around your signature so that a frame won't cover it. Use a small round brush with thinned paint in a contrasting color, or use a fine-line permanent marker. Practice your signature or an identifying mark until you are happy with the look.

Include the year by adding it after your signature or by putting it on the back of your work. Make sure it doesn't bleed through to the front.

It's wise to add a copyright notice on the back of your work or discreetly on the front. For example, "©2018 Marjorie Sarnat." This is an important safeguard for artwork and prints that you would like to sell.

210 BELIEVE IN YOUR NATURAL INSTINCTS

When it comes to art, no rules are hard and fast. Every artist has their own truth and a natural direction. Remember this as you journey along in your personal artistic direction.

APPENDIX

The Art of Naming Art

A Picture Is Worth a Few Good Words

The title of your piece sets a mood and provides insight into what you hope the viewer will see and feel in your work. I think of titling a painting as a bit like writing poetry—using words for creating moods and conveying intangible ideas. Titles such as *Doorway to a Dream, Echoes Through Mountains,* and *To Catch a Moonbeam* suggest a mood rather than a clear visual description.

Some art may work best with titles that convey a visual description, such as *Study in Vermilion and Blue, Painting Outside the Lines,* and *Maple Trees After the Morning Snow.*

Viewers want to understand your visual narrative so they can get emotionally involved. They want to know what you are showing them and why. Don't fully explain your work, but give them a clue. Leave a little ambiguity for the viewers to interpret.

Different Strokes

Some artists have a knack for naming their artwork as an extension of their creative expression. It's been a challenge to come up with titles that fit my art and elicit the emotional response I want. Like most artists, my work is visual, not verbal.

I know artists who don't think about titles until their artwork is finished and they see what their paintings evoke. Other artists have a title in mind as they create. Many artists start thinking about a title in the middle stages of a painting, as their imagery takes shape. There are no definite rules for titling a painting.

I've developed some approaches to help you generate titles.

+ Ask yourself what you want the viewer to know, see, or feel. When you formulate a title, consider whether the words help get that across.

+ Write down some key words from your painting, such as "dandelions, pink shadows, abandoned barn, calm, and years gone by." Select the words that best suggest your painting and try to form a title. Maybe a single word, *Dandelions,* tells the story of abandonment. Maybe you want to put a haunting spin on your piece with the title *Quiet Barnyard Sounds* or a sad note with *The Silence Is Deafening.* Perhaps you simply wish to describe a picture, *Pink Tones Across a Field.*

- ✦ Put yourself in the viewer's shoes. The viewer doesn't know anything about you or your painting. Will your title help them correctly respond to your artwork?

- ✦ The sound of your words makes a difference. Alliteration, such as *Runaway Rosebuds*, can make your titles appealing and memorable.

Choose words that are comfortable to read and say. I dislike words that are unfamiliar, such as "Whilom," and unpronounceable, such as "Mr. Fzaeuhgbheau's Isthmus." However unique your title's idea, use words your viewers can grasp.

Twelve Title Types

There are various kinds of titles. Experiment with them to see what fits your painting's message best. Keep in mind that every painting has more than one good possibility.

1 **Abstract Visual**, such as *Checkerboard Swirl*

2 **Descriptive**, such as *Lake Michigan Looking North*

3 **Intangible**, such as *Optimism*

4 **Metaphoric**, such as *Bathing Beauty* (a pig in mud)

5 **Mysterious**, such as *Dancing with Myra* (with no person or creature in the picture)

6 **Nostalgic**, such as *When Grandma Was a Girl*

7 **Numerical**, such as *Surface #7*

8 **Philosophical**, such as *Do Unto Others*

9 **Prismatic**, such as *Turquoise Green*

10 **Reference**, such as *Alexandria Revisited*

11 **Technical**, such as *Encaustic on Weathered Wood*

12 **Tenderhearted,** such as *Alice's First Puppy*

Combinations of these, such as *Alizarin Crimson at Sunrise*, also work. You'll likely think of other categories, but the examples above can help give you a jump start.

Become a Collector

Keep a reference file of potential painting titles. Include any words or phrases that intrigue or appeal to you. I call them "Title Makers." Play with the words and make them your own. Find word inspiration in:

✦ Art history, ancient and contemporary

✦ Lines from movies

✦ Literature (Look for book titles, quotes, and lines from literature to adapt and make your own.)

✦ Names from mythology

✦ Names from nature

✦ Names of colors in fashion, cosmetics, wall paint, and more

✦ Names of other artworks (Never copy another artist's titles, but keep some great ones on file as examples.)

✦ Names of things that have symbolic meaning, such as butterflies, pillars, mirrors, and clouds.

✦ Phrases you hear or read (Jot down anything that's evocative, provocative, insightful, beautiful, mysterious, or shocking.)

✦ Poetry (Scan for phrases and rhythms of word-sounds you like and words that create moods, and then adapt them to make them your own.)

✦ Song lyrics (Listen for rhythms of word-sounds and phrases that express emotion, and then adapt them to make them your own.)

✦ Spiritual and biblical references

✦ Terms from astronomy

✦ Words that describe feelings, moods, and intangible ideas (A thesaurus is a rich source.)

Making a Name

As an artist, making a name for yourself involves creating great art and marketing it well. Coming up with good titles is part of the creative process. That means "Making a Name" is important in more than one way.

GLOSSARY

Aboriginal Art: Art that is native to the Australian Aboriginals. Their traditional art forms are inspired by spirituality and employ colors and motifs for their symbolic meanings.

Abstract Art: Imagery that departs from the representational to greater or lesser degrees, often to the extent that it is not recognized as anything tangible. Robert Rauschenberg, Jasper Johns, and Robert Motherwell were leading abstract artists.

Abstract Expressionism: An art movement that began in 1940 and was prominent in New York. It combines abstract and nonobjective art forms with emotional content and the expression of the individual. It's generally characterized by spontaneous, bold, and energetic applications of paint and includes a wide variety of styles. Franz Kline was a leading Abstract Expressionist.

Abstract Illusionism: The use of visual illusions to imply reality, such as shadows, color contrasts, and size changes to show distance. It creates visual deception for intangible subject matter.

Aesthetics: The principles and standards of beauty and artistic taste.

Analogous Colors: Colors that are adjacent on the color wheel.

Art Movement: A style in art with a common philosophy or goal, practiced by a group of artists during a certain period of years. Art movements were especially notable in modern art, when each new art movement was considered as the leading avant garde. Some of these include Impressionism, Surrealism, and Pop Art.

Art Nouveau: A style of decorative art and design that was popular in the Western world in the late nineteenth century through the early twentieth century. It's characterized by the use of stylized organic motifs and dramatic curved lines.

Ashcan School of Painting: A realistic art movement that was prominent in the United States in the early twentieth century. It's known for portrayals of everyday life in the poorer neighborhoods of New York City.

Assemblage: An art method similar to collage, in which the artwork is built up with a combination of three-dimensional materials, such as found objects, manufactured items, and handmade items. These can be both freestanding works or bas-reliefs.

Automatons: Moving mechanical devices that imitate human activities. These were popular parlor items in the Victorian era.

Avant-garde: Artwork or ways of making art that are characterized by unorthodox ideas and methods.

Bas-relief: Relief refers to a sculptural form that is not freestanding but has a background similar to a painting, but in which the surface is sculptural. There are various levels of depth in relief. Bas-relief refers to a middle level, as opposed to high relief (the most depth) or low relief (least depth).

Blue Period: The works produced by Spanish painter Pablo Picasso from 1901 to 1904, when he produced monochromatic paintings in blue and blue-green colors.

Cartography: The art and science of making maps.

Collage: An art form where various materials, papers, photos, and more are arranged and adhered on a surface.

Colorist: A painter who is concerned with the interactions of colors, who exaggerates colors, or who uses color in unusual ways.

Color-Field Painting: A style of abstract painting that began in New York in the 1940s. Fields of flat, solid color are spread across a large canvas. The color is free from objective imagery and becomes the subject itself. Mark Rothko was a leading color-field artist.

Color Story: A limited group of colors that elicit a mood or reference a style, an era, or things in nature.

Color Wheel: An arrangement of colors around a circle to show the relationships between primary, secondary, and tertiary colors and sometimes neutrals. Artists use it as a guide for mixing colors and selecting color schemes.

Complement or Complementary Color: A color that falls opposite to a given color on the color wheel.

Conceptual Art or Conceptualism: Works of art where the concepts or ideas behind them take precedence over traditional aesthetic concerns.

Cubism: An art style developed in 1907 in France by painters Georges Braque and Pablo Picasso. Objects and figures were shattered apart and depicted as cubes and other geometric shapes with straight angles, then assembled together again. Cubists attempted to show all the sides of an object in the same painting. They also used muted colors that didn't show depth.

Cuneiform Script: One of the earliest known systems of writing, originating in Sumer in the 4th millennium B.C.

Dadaism: An art style originated by European avante-garde artists in the early twentieth century. They rejected logic and instead expressed nonsense and irrationality. This was done to protest violence and war. Examples of Dadaist artworks are fur-lined coffee cups and bicycles with square wheels.

Deconstructivism: A conceptual style of design that has roots in the 1960s and became popular in the 1980s in the United States. The style is characterized by exposing the underlying structure of the physical product and often shows unconventional components and unorthodox methods of assembly.

Decorative Art: Art that has value for its decorative and beautiful qualities rather than as a statement with deeper meaning.

Diptychs: Works of art in two parts that are intended to be displayed next to each other. They may or may not be physically joined.

Dislocation: A technique in art used by surrealists in which things are placed in unlikely proximity to each other, in unlikely settings or contexts, or in unnatural scale within their surroundings and with other objects.

Drip Painting: A form of abstract art in which paint is poured onto the canvas or substrate. This style of painting was first made popular in the mid-twentieth century by artist Jackson Pollock.

Elements of Art: The building blocks of visual arts, usually considered to be color, form, line, shape, space, texture, and value.

Emoticons: Representations of facial expressions and other images using punctuation marks and the characters on computer keyboards.

Environmental Artists: Artists whose work actively participates in the landscape rather than only depicting it. Such artists alter the environment by adding aesthetic elements into it. They're often concerned with ecological issues. Environmental artists emerged in the late 1960s.

Expressionism: An approach to making art that uses the artist's emotions for inspiration.

Fauvism: A French word meaning "the wild beasts," in which a group of early twentieth century French artists emphasized painterly styles and exaggerated color over more representational depictions.

Figurative Art: Artwork that uses representations of people, animals, or living things as subject matter.

Formalism: The point of view that the most important aspect of a work of art is its arrangement of the elements of art.

Free-form Shape: A shape that is asymmetrical or that has irregular outlines, rather than being geometric or symmetrical.

Frottage: The process of making an image on paper by rubbing over a textured surface with a pencil or coloring material to use as an element in artwork.

Grisaille: A monochromatic painting, usually in gray, to serve as an underpainting for color glazes and paint applications.

Hard and Soft Edges: A hard edge refers to the edge of an object being painted in a defined way, with a clear boundary. Soft edge refers to the edge of an object being painted with an unclear boundary that may blend into its background. Edges are also referred to as "lost and found" edges (soft and hard). The way an edge is handled has much to do with the focus of areas within a painting.

Illusionism: The use of visual illusions to imply reality, such as shadows, color contrasts, and size changes to imply distance and create visual deception.

Impasto: The heavy application of paint, often displaying brushstroke or painting knife textures.

Impressionism: A style of painting originated and developed in France in the 1870s. It was inspired by the immediate visual impression elicited by a scene and characterized by the use of unmixed pure colors with small brushstrokes to depict actual reflected light.

Installation Art: Three-dimensional artwork that needs to be located at specific sites as part of its statement.

Instinctive Style: Art that is created according to the artist's inherent or intuitive sense of aesthetics rather than by acquired knowledge or traditional training.

Intangible: That which cannot be touched and does not have material properties.

Intensity of color: The brightness or dullness of a color.

Interpretation: An individual's way of determining the meaning of something, with unique viewpoints and visualizations.

Intuitive Painting: A spontaneous approach to painting that is directed by feeling rather than thought.

Juxtaposition: Placing things side by side. In surrealist art, the term "unexpected juxtaposition" is often used to indicate things that are side by side but do not logically belong together or things that appear in an unnatural context.

Light Bridges or Bridges of Light: The shapes of areas of light falling on objects and visually connecting to each other. The light forms a visual bridge across elements in a composition.

Lost Edges: Edges of a form that are unseen by blending them out or by not depicting them in an artwork.

Mandala: A circular design with a center point from which emanates geometric shapes, organic forms, symbolic imagery, colorful visions, and imaginative subject matter. Mandalas have ancient spiritual history.

Metaphor: The use of an object, scenario, or idea to represent something else.

Micro-naturalism™: A term coined by the author to refer to art that depicts microscopic life and imagery.

Minimalism: An art movement that endeavors to expose the essence of a subject. It rejects detail and superfluous aspects and often uses geometric abstraction and hard edges of color for its depictions.

Mixed Media: Combinations of media and materials.

Monotone or Monochromatic: Use of a single color.

Multi-monotone: Artwork using a single color and its grades of value, intensities, and various hues that lean toward its analogous colors on the color wheel.

Naturalism: A representational art form that does not idealize the figure or object but rather depicts things as naturally as they appear to the artist. This term is often used in place of realism.

Negative Spaces: The area not occupied by objects, or the shapes made by empty spaces around and outside the objects. Negative space helps describe objects and provides a backdrop for them.

Nonobjective or Nonrepresentational Art: Art that does not visually depict anything tangible.

Ombré: The graduation of blended colors or values of a color, usually on fabric.

Op-art: A style of visual art that makes use of optical illusions. The movement was inspired by ideas from the Bauhaus in Germany and took root in Chicago in the early 1960s.

Optical Color Mixing: Small dots, dabs, and commas of pure paint color that the eye mixes when viewed from a distance.

Outsider Art: A term coined in the 1970s to describe art created outside the boundaries of a mainstream art community. It originally portrayed extreme mental states and outrageous ideas but now refers to any art that's created only for personal expression.

Pattern: The repetition of an element in an artwork.

Plein Air: A French phrase that means "in the open air" and refers to painting landscapes outdoors to make use of natural light. *Plein air* painting gained popularity in the 1870s and endures today.

Pointillism: A technique of painting in which small dots of pure color are applied to form an image when viewed from a distance. It relies on optical mixes of colors. French painters Georges Seurat and Paul Signac developed the style in the 1880s.

Pop Art: An art movement that began in the 1950s in Britain and the United States. It's a concept that breaks with tradition in fine art and uses imagery from popular culture, such as consumer products, comic books, logos, and advertisements. Roy Lichtenstein and Andy Warhol were leading pop artists.

Principles of Art: The guidelines and rules of aesthetics that artists use to arrange the elements of art for creating an artwork.

Public Domain: There is no copyright, trademark, or owner of a work who requires you to pay a fee or who can legally prevent you from using the work.

Realism: Art that represents the subject truthfully and naturally without implausible, supernatural, or nonobjective elements.

Representational: A style of art that uses subject matter the viewer can recognize.

Steampunk: A design style used in science fiction that is set in the late nineteenth century. It is characterized by the use of mechanical parts such as gears and springs.

Still Life: A painting featuring an arrangement of inanimate objects, either man-made or from nature.

Style: A distinctive manner of visual expression.

Surrealism: The depiction of the artist's subconscious mind and visions through representational objects that are freed from their usual associations and contexts.

Symbolism: The representation of something that's intangible (often spiritual, emotional, or political) by a material object.

Tangible and Intangible: Tangible: capable of being touched or an actual physical material. Intangible: Imaginary or visionary with no physical properties.

Technique: A method of applying paint or creating images on a surface.

Trash Art: Mixed media contemporary art created with familiar and discarded items.

Triptychs: Works of art in three parts intended to be displayed next to each other. They may or may not be physically joined.

Upcycled Art: Art made from recycling, reusing, and repurposing discarded materials.

Value of Color: How dark or light a color is.

Veil Painting: A way of applying watercolor devised by the Waldorf School. Watercolors are thinned down to a very light value and wet colors are applied over dry colors, one layer at a time, as if the colors were veils. Often there is no underlying drawing, which allows the veils to emerge and take form.

Viewfinder: A small rectangle cut into a card or made by the hands forming a frame. Viewfinders isolate a scene or section of an image to help an artist find and evaluate a composition.

Visual Interpretation: The way an artist sees or chooses to portray a subject.

Visual Metaphor: The visual depiction of something to represent something else.

Visual Narrative: The story an artist tells through visual elements in an artwork.

Visual Statement: The idea or concept an artist expresses in an artwork.

RESOURCES

These are my favorite resources. Each time I refer to them, I understand the information in new ways. Add your own favorites to the list and refer to them for inspiration and information.

BOOKS

✦ *Rethinking Acrylic*
by Patti Brady
North Light Books, Cincinnati, Ohio, 2008
Wonderful, playful, unusual techniques for acrylics. The techniques are clearly shown and explained.

✦ *Emotional Content: How to Create Paintings That Communicate*
by Gerald Brommer
International Artist Publishing, Inc., Verdi, Nevada, 2003
Too often artists focus on painting techniques as the key to creating powerful paintings. This well-known watercolorist and art instructor explains that emotional content is the most vital consideration. He shows how the grouping of visual elements and the prominence given to each element by the way they're depicted influences how observers perceive paintings. This is an important topic rarely addressed in the multitudes of art instruction books. Included are many beautiful examples of the author's paintings.

✦ *Loosen Up*
by Robert Burridge
Robert Burridge Studio, Arroyo Grande, California, 2011
Fundamentals of contemporary painting presented with inspiration and encouragement. Open this book to any page at random, and find treasures of help.

✦ *The Crafter's Devotional*
by Barbara R. Call
Quarry Books, Beverly, Massachusetts, 2009
An inspiring collection of tips and techniques on journaling, creative recycling, and mixed-media crafts, which can be interpreted in fine art paintings.

✦ *Creative Composition & Design*
by Pat Dews
North Light Books, Cincinnati, Ohio, 2003
This volume is packed with solid foundational information for artists working in any medium or style. Excellent photographs represent a broad variety of styles.

✦ *Conversations in Paint: A Notebook of Fundamentals*
by Charles Dunn
Workman Publishing, New York, 1995
Open this book at random to any of the double-page spreads and you'll find clearly illustrated truths about great paintings, and you'll be inspired to paint. This book is a wonderful companion for artists who wish to keep to the basics but don't want to read hundreds of pages from an assortment of volumes.

✦ *Designs by Erté: Fashion Drawings and Illustrations from "Harper's Bazar"*
by Erté
Dover Publications, Inc., New York, 1976
This book of drawings by Paris-based artist Erté shows stylized fashions and theater designs of the 1910s through the 1920s. Rather than looking to the book only for fashions, the drawings hold a treasure trove of stunning design details, drawing techniques, and composition ideas that can be applied to other kinds of art-making.

✦ *120 Great Impressionist Paintings*
(CD-ROM and Book)
by Carol Belanger Grafton
Dover Publications, Inc., New York, 2007
Van Gogh's famous sunflowers, Monet's beloved waterlilies, and scenes by Renoir and Manet of sun-dappled leisure all appear in this collection of the best and most popular Impressionist paintings. Additional contributors include Degas, Toulouse-Lautrec, Gauguin, Pissarro, Cassatt, and Seurat.

✦ *120 Great Maritime Paintings*
(CD-ROM and Book)
by Carol Belanger Grafton
Dover Publications, Inc., New York, 2009
From tranquil vignettes of oyster harvesting to tumultuous scenes from historic naval battles, this collection contains an outstanding variety of reproductions of masterful works. Featured paintings include Winslow Homer's *Breezing Up*, 1876, and Claude Monet's *The Cliff at Etretat*, in addition to works by Manet, Cassatt, and Hassam.

✦ *Great Animal Drawings and Prints*
by Carol Belanger Grafton
Dover Publications, Inc., New York, 2006
From Rembrandt's monumental elephant and Toulouse-Lautrec's prancing circus steed to Rubens's masterly brush-and-ink study of a lion, this unique collection portrays all manner of creatures from the animal kingdom. More than 100 illustrations—17 in color—include magnificent works by Hieronymus Bosch, Albrecht Dürer, Anthony van Dyck, Francisco Goya, Leonardo da Vinci, Pieter Bruegel the Elder, Diego Velazquez, Fra Bartolomeo, Katsushika Hokusai, John James Audubon, Edgar Degas, Pablo Picasso, and many other masters. An archive of works by artists from Renaissance luminaries to twentieth-century masters, this book is a treasury of beautiful approaches for artists who love to portray animals.

✦ *Arteffects*
by Jean Drysdale Green
Watson-Guptill, New York, 1993
Clear in-depth explanations for interesting fine art techniques for a variety of art media.

✦ *Color and Light: A Guide for the Realist Painter*
by James Gurney
Andrews McNeel, Kansas City, Missouri, 2010
James Gurney is both a great master and a great instructor. This book not only explains all the effects of color and light a representational artist may encounter, but it thrills us with his stunning paintings shown as examples.

✦ *Intuitive Composition*
by Albert Handell and Leslie Trainor Handell
Watson-Guptill, New York, 1989
Based on the belief that intuition is behind good design in paintings, the book covers the basic elements of composition along with personal preferences. This volume spans the gap between rigid adherence to "the rules" and expression through one's own sensibilities. Of all the books I've read on composition, I find this approach the most realistic for the way I actually proceed to paint. Although the book is out of print, it's worth tracking down a good used copy.

✦ *The Map as Art: Contemporary Artists Explore Cartography*
by Katharine Harmon
Princeton Architectural Press, New York, 2010
Exciting interpretive map-art of the world—and beyond.

+ *Hawthorne on Painting*
 Collected by Mrs. Charles W. Hawthorne
 Dover Publications, Inc., New York, 1960
 First published by Pitman Publishing Co. in 1938
 For 31 years, Charles Hawthorne spoke to his students at his famous Cape
 Cod School of Art, offering pearls of wisdom that stand the test of time.
 Every artist will find insight and inspiration in this little book of artistic
 truths. His words were collected from the notes of his students and compiled
 by his wife. I have opened this book at random, and every passage is not only
 meaningful to me, as a working artist today, but makes me excited about
 being an artist.

+ *The Art Spirit*
 by Robert Henri
 J. B. Lippincott Co., Philadelphia, Pennsylvania, 1923
 The collected words and teachings of artist Robert Henri are a timeless
 source of wisdom and inspiration for every artist.

+ *Modern Artists on Art*
 Edited by Robert L. Herbert
 Dover Publications, Inc., New York, 2000
 This amazing anthology contains 17 essays by some of the twentieth
 century's leading artistic innovators, such as Kandinsky, Le Corbusier, Klee,
 Malevich, Ernst, Mondrian, and Schwitters. The essays are readable, thought-
 provoking, and they provide insight into the ideas behind some of greatest
 modern art movements.

+ *7 Keys to Great Paintings*
 by Jane Hofstetter
 North Light Books, Cincinnati, Ohio, 2005
 The book includes a fabulous illustrated chapter on patterns as the underpin-
 nings of paintings along with terrific chapters on color and composition.

+ *Color on Paper and Fabric*
 by Ruth Issett
 B. T. Batsford, Ltd., London, 1998
 This book offers sumptuous illustrations of colorful surface treatments.
 What's unique is that it treats using fabrics as substrates for fine art
 applications rather than focusing mainly on craft applications. The book
 clearly explains a wealth of techniques for applying and celebrating
 color. Although the book is out of print, good used copies are worth
 tracking down.

+ *200 Great Painting Ideas for Artists*
 by Carole Katchen
 North Light Books, Cincinnati, Ohio, 1998
 An array of inspiring artworks and ideas from several successful artists
 working in a variety of media.

+ *Leonardo da Vinci's Advice to Artists*
 Edited and annotated by Emery Kelen
 Running Press Book Publishers, Philadelphia, Pennsylvania, 1990
 Powerful tips from one of the world's greatest masters. Here is the source of
 many classic truisms in art.

+ *Problem Solving for Oil Painting: Recognizing What's Gone Wrong and How to
 Make it Right*
 by Gregg Kreutz
 Watson-Guptill, New York, 1997
 What sets this book apart from others is that it shows unsuccessful paintings
 and discusses how to strengthen them. We see the improved results.
 Sometimes the reason a painting doesn't work well is not immediately
 obvious. The author shows how the underlying problems center on the
 fundamentals such as composition, space, values, and color.

+ *Color in Contemporary Painting: Integrating Practice and Theory*
 by Charles Le Clair
 Watson-Guptill, New York, 1991
 This book thoroughly explains how to use color in contemporary oil,
 acrylic, and watercolor painting. Rather than stop at theory, it addresses
 the various ways masterful artists employ color. The book is filled with
 examples of paintings by past masters along with works by acclaimed
 contemporary artists.

+ *Surface Treatment Workshop: Explore 45 Mixed-Media Techniques*
 by Darlene Olivia McElroy & Sandra Duran Wilson
 North Light Books, Cincinnati, Ohio, 2011
 This book is a feast for creative minds. Concise explanations and extensive
 imagery serve as a launching pad for artists who wish to develop their own
 looks and invent exclusive techniques.

✦ *101 Great Illustrators from the Golden Age, 1890–1925*
by Jeff A. Menges
Dover Publications, Inc., New York, 2017
The most comprehensive book of its kind, this gorgeous edition presents more than 600 works, over 350 in full color, by famous and lesser-known artists from the heyday of book and magazine illustration. Featured artists include Walter Crane, Edmund Dulac, Maxfield Parrish, Howard Pyle, Arthur Rackham, and N. C. Wyeth. Every image is a delight.

Additional artists include Victorian-era illustrator Aubrey Beardsley, noted for his compelling combinations of the erotic and grotesque; American painter Harvey Dunn, one of Howard Pyle's most accomplished students; James Montgomery Flagg, famed for his U.S. Army recruitment posters; Charles Dana Gibson, creator of the iconic Gibson Girl; Charles R. Knight, a pioneer in the depiction of dinosaurs and other prehistoric creatures; Edward Penfield, the king of poster art; Frederic Remington, whose works document the Old West; and J. Allen St. John, the principal illustrator of Edgar Rice Burroughs's adventure tales.

✦ *120 Great Victorian Fantasy Paintings*
(CD-ROM and Book)
by Jeff A. Menges
Dover Publications, Inc., New York, 2009
The Victorians were enthralled by fairies and angels, and their fascination with benevolent spirits is reflected in their art. These full-color paintings from the nineteenth and early-twentieth centuries feature pre-Raphaelite, symbolist, and narrative works by such noteworthy artists as Waterhouse, Burne-Jones, Draper, Watts, and Grimshaw. These images are breathtakingly beautiful examples of fine draftsmanship and color harmony.

✦ *Once Upon a Time . . . A Treasury of Classic Fairy Tale Illustrations*
Selected and Edited by Jeff A. Menges
Dover Publications, Inc., New York, 2008
This enchanting gallery transports viewers to a fairy tale world—an ageless fantasy realm inhabited by characters from favorite folktales and depicted by renowned artists. Lovingly reproduced from rare early editions, more than 180 illustrations portray scenes from stories by the Brothers Grimm, Hans Christian Andersen, and other sources, including ancient Celtic and Norse legends. Breathtaking art, dating from 1882 to 1923, captures the genius of 23 illustrators, including Arthur Rackham, Gustave Doré, Edmund Dulac, Kay Nielsen, Warwick Goble, and Walter Crane. There are imaginative interpretations from scores of familiar and lesser-known tales. Many of the illustrations are brilliantly colored, full-page images. This treasury is a happy marriage of fine art and fairy tales.

✦ *Finding Your Visual Voice: A Painter's Guide to Developing An Artistic Style*
by Dakota Mitchell
North Light Books, Cincinnati, Ohio, 2007
Ideas and exercises for discovering your creative vision and true visual voice.
Includes many examples of paintings in a variety of styles.

✦ *The Fantasy Artroom*
Written and Illustrated by Aaron Peacock
Dover Publications, Inc., New York, 2016
This beautiful book will help you brush up on your skills and add new
techniques to your repertoire. It offers step-by-step instructions for drawing
trees, landscapes, and mythological creatures, and shows how to put them
together in compositions. While the book is geared toward artists working in
the fantasy genre, the information is universal.

✦ *Acrylic Revolution*
by Nancy Reyner
North Light Books, Cincinnati, Ohio, 2007
Another collection of fun tricks and techniques for acrylics. The techniques
are clearly shown and explained.

✦ *About Sketching: The Art and Practice of Capturing the Moment*
by Jasper Salwey
Dover Publications, Inc., New York, 2017
Written as a sketching artist's companion, this illustrated guide by a noted
author of art instruction manuals speaks to the value of sketching as an art
form unto itself. Salwey details the advantages of various drawing media,
from pencil to watercolor, and their best applications. For artists and
students, with moderate to advanced skills, who love to draw.

✦ *Creative Genius: How to Grow the Seeds of Creativity Within Every Child*
by Marjorie Sarnat
Jr Imagination, Los Angeles, 2012
The creative process is the lifeblood of every artist. Although I wrote this
book as a guide for teachers to foster creative thinking in students, the book
works for everyone. It includes an overview of how the creative process
works and how it can be employed to generate new ideas; other parts of the
book offer art exercises that could inspire fine art endeavors.

◆ *Creativity Unhinged: 120 Games for Kids to Spark Their Imaginations*
by Marjorie Sarnat
Jr Imagination, Los Angeles, 2013
The author wrote this book as a collection of fun five-minute games to
exercise creative thought in children and adults. Use them as warm-ups to
get your creative juices flowing.

◆ *The Artist's Muse: Unlock the Door to Your Creativity*
by Betsy Dillard Stroud
North Light Books, Cincinnati, Ohio, 2006
Prompts and idea sparkers to boost your creativity in art.

◆ *Helen Van Wyk Books: Color Recipes; Color Recipes 2;* and *Welcome to My
Studio*
by Helen Van Wyk
Art Instructions Associate, Sarasota, Florida, 2000–2002
Former art instructor turned author Helen Van Wyk offers wonderful,
clearly stated explanations, tips, and inspirations for painters. I recommend
using her solid foundational information as guidelines from which you can
detour and forge your own path.

◆ *Colour and Light in Oils*
by Nicholas Verall
B. T. Batsford, Ltd., London, 2008
The artist's impressionistic style shows glowing color in such a beautiful
way that I couldn't resist buying this book. Verall discusses color in light
and in shadow, while images of his paintings themselves provide additional
information on the subject.

INSPIRING ARTISTS AND ARTWORKS

The following is a broad range of approaches for making wonderful art by contemporary artists. When gathering these examples, I looked for distinctive styles and masterful handling of materials. Of course, there are thousands of artists' works worthy of mention, but for practical reasons, I limited the list to reflect a small sampling of diverse approaches to painting. The artists and artworks mentioned here can be found online. Add your own favorites for future inspiration.

✦ Installation artists **Christo** and **Jeanne-Claude** alter actual landscapes in ways that transport one to a new world, while suggesting an eerie familiarity as well.

✦ **Ian Davenport** and **Melanie Rothschild** are among the artists who create amazingly beautiful drip-gravity paintings. Drip painting is often done by rotating large canvases on a wall.

✦ **Tom Deininger** creates gorgeous portraits and more from discarded and recycled materials. You won't believe your eyes.

✦ **Brian McKenzie** portrays "animalcules," imaginative beings inspired by early depictions of microorganisms. Scientists were astonished when they discovered living organisms that cannot be seen with our natural eyes.

✦ **Mark Carder** creates beautifully planned portraits and landscapes in the style of the old masters, using his own brand of oil paints and measuring tools.

✦ If you love books and art, then **Stanford Kay**'s paintings will delight. His paintings of multitudes of books on shelves capture the abstract rhythm while being realistic representations at the same time.

✦ **David Sloan** looks for images of curious interest as he wanders through a city. He makes his discoveries the subjects of beautiful drawings and paintings.

✦ Check out the colorful, curvilinear, retro-inspired paintings by **Ivey Hayes**. All are wonderful to behold, but his jazz musicians are my personal favorites.

✦ **Steve Henderson** creates glorious figurative paintings. His illustration background provides a solid foundation for his exuberant impressionistic brushwork.

✦ I have long admired the artwork of **Maryann Thomas**, an extraordinarily accomplished watercolorist.

- **Karen Feuer-Schwager** calls her work neo-Expressionism, with imagery derived from her dreams. The multilayered surface materials contribute to a compelling tactile, as well as visual, effect. Her "Works on Paper" series and "Tea Bag Paper" series are my favorites.

- **Kat Corrigan** does something impressive: She goes on painting sprees to produce 30 dog paintings in 30 days. I love the way she uses fresh, unexpected color and makes it work. Her website is a delightful tour of the world of an animal-loving artist.

- **Aviva Kramer** explores the relationship between the physical and the metaphysical, seeking to illuminate the unknowable through color and organic forms.

- **Marian Devney**'s collages incorporate vintage imagery in a direct yet subliminally engaging way. Her witty art will make you smile.

- **Lore Eckelberry** has a bold, distinctive style that combines solid drawing skills with the imaginative use of patterned papers. She often paints onto skateboards that have been braced together to form an unusual "canvas."

- **Tom Stewart** is inspired by his lifelong affinity for the sea. He captures its ebb and flow, watery textures, and wondrous visions in mixed media by combining oil crayon, wax, watercolor, and ink to achieve a distinctive representational style.

- **Phil Hansen** is both inspired and an inspiration himself. He turned a tremor that causes his hand to shake into a gorgeous black-and-white style all his own. He uses dots and dashes, stamping (feet and more), and other unusual ways of making marks to create surprisingly realistic images on large canvases.

- The beautiful drawings of **Max Turner** capture form as only an artist who also sculpts could portray. His lyrical lines and subtle shadows come alive on a page.

- Collage artist **Tanya Mikaela** combines her deep spirituality with environmental consciousness in her beautiful "Brown Bag Buddha" series.

- **Marilyn Stempel** approaches watercolor with a spontaneity that results in organic, painterly imagery.

- **Mark Bradford**'s immense collages use innovative materials from which he produces gorgeous, rhythmic artworks.

- **Mara Thompson** has a wonderful series titled "Pick a Card . . . Any Card." The series portrays artist trading-card compositions within a narrative, within a painting.

- **Joan Foster**'s artwork is characterized by her mastery of subtle colors; she makes grays glow. Her compositions are tranquil and beautiful.

- A self-proclaimed sociologist, **Kathi Flood** makes farcical, narrative assemblages and installations that "heroicize" the less-than-glamorous aspects of the human condition in modern life. And she does so with humor and aesthetics.

- **Andrea Raft** depicts the complex textures of nature while using glowing earthen hues in her serene compositions.

- **Connie Tunick** paints sumptuous flowers in watercolor, and her mixed media compositions are exceptionally strong.

- **Dan Thompson**'s figurative, still-life, and landscape paintings are astoundingly gorgeous. Each painting seems to be washed in an atmosphere of color, while rich, luminous tones emerge through. Notice his play of warm against cool hues. His drawing skills are superb too.

- Classical chiaroscuro painter **Sherrie McGraw**'s artwork is a wonder to behold. She brings a contemporary sensibility to traditional painting techniques. Her drawings are gorgeous as well.

- Masterful artist **David A. Leffel** paints in a philosophical process he calls nature "intelligence." He seeks to paint the "life" aspect of his subjects, and however he perceives that, his subjects—whether peaches in a still life or a person in a portrait—breathe with life. Seeing is believing—and a beautiful experience as well.

- **Ignat Ignatov** brings a unique, expressive richness to the techniques of the old masters. Among his radiant still lifes, sensual figurative pieces, and dramatic landscapes, his doorways and interiors haunt me with their intriguing beauty.

- If you delight in the vintage relics of days gone by—and you appreciate skilled watercolor photorealism—you won't want to miss viewing **Judy Koenig**'s artwork.

- **Josephine Wall** paints imaginative, feminine, and beautifully realized fantasy subjects. Her style is highly detailed and reveals her dreamy surrealist world. As a generous gift to fans, she demonstrates how she develops her amazing paintings from start to finish!

- If you love intricate patterns described in line work, you'll find a piece of heaven in this artist's work. **Annika Sylte** uses line with grace and imagination.

- See **Angelo Franco**'s contemporary handling of Pointillism and Impressionism. His colors are vibrant and gorgeous.

- **Scott Yeskel**'s realistic and abstract paintings are filled with rich, glowing color harmonies. His artwork is simply beautiful.

- The website of **Judith Walker** showcases her unusual paintings, which are all about emotion in color and pattern as well as incorporating written messages into art. Read her thought-provoking artist's statement about the effects of written messages in art. Among her works, *Inferno Terra Paradiso Series 1* and *Paintings with Words* are my favorites.

- **Gwen Samuels** works with surface patterns in the most interesting of ways. Don't miss viewing her dresses, nature, architecture paintings, and sculpture. This work is truly distinctive.

- Collage artist **Derek Gores** paints with recycled magazine pages. Gorgeous and amazing, his pieces look like painterly representational oil paintings, but they're something else!

- Philippines painter **Jef Cablog** creates magnificent works that form bridges connecting masterful skills to contemporary treatments and spiritual meanings. His artwork is unique and astonishingly beautiful.

- **Dorrie Rifkin** explores patterns and designs that are characteristic of city scenes. They are fresh and evocative examples of "in-and-around New York City" as subject matter.

- **Gary Soszynski** is one of the most creative, prolific, and accomplished artists I have had the good fortune to know and work with. His work is spiritual, surrealistic, and masterful.

- **Carol Surface**'s multilayered pieces are rich with vibrant colors played against subtle colors and levels of texture throughout. Crowded city environments provide the metaphors for her "organized chaos" paintings and wall sculptures.

- **Dina Herrmann**'s beautiful, colorful surfaces are exciting and inspiring. I describe some of her pieces as abstract expressionism meets allover pattern. Although her extensive body of artwork all carries her signature style, each series clearly differs from the other.

- **Nancy Goodman Lawrence**'s Circle Series collages are intricate and intriguing. Each piece starts with a perfect circle at the core that becomes more distorted as the composition moves outward.

- Japanese-born California artist **Fumiko Amano** paints masterful floral images that appear familiar and vaguely dreamlike at the same time. She explains that her paintings are inspired by musical sound. If you love radiant color, you'll love her work; you can "hear" it.

- **Ann Thornycroft** honors pattern and color with beautiful and captivating results.

- **Kwei-lin Lum** has taken her passion for paper dolls and elevated it to a fine art form. Her concepts and designs are unique, brilliant, and beautiful. After viewing her artwork, you'll never think of paper dolls as just a childhood activity again.

- Russian master painter **Sergei Bongart** creates magnificent, light-filled paintings that glow with emotion and radiant color.

- **Lynn Gertenbach**, an award-winning Impressionist and *plein air* painter, creates beautiful works. She also has an informative blog.

- **Andrea Joseph** brought the art of sketching to fine art status. Her subject choices and her eloquent style make you want to grab a pencil and record all the details that delight you in your own life.

- **Daniel Edmondson** is an accomplished artist whose still-life works, landscapes, and figurative paintings are reminiscent of the classical old masters.

- **Karen Mathison Schmidt**, a fabulous landscape and figurative painter, is a true colorist who doesn't simply make color "work." She honors it. If you like dogs and cats, you'll love her pet portraits.

- *Plein air* landscape artist **Sharon Weaver** has won many awards for her luscious and masterful paintings.

- **Nathan Fowkes** is a concept artist for animation and entertainment projects as well as a great fine-art artist. His incredible paintings have a gem-like quality.

- If you have a passion for pattern and the interaction of colors within pattern, **Joanne Mattera**'s art will gladden your heart. It elevates pattern and surface texture to fine-art status, where it belongs.

- *Dinotopia* creator **James Gurney** is an inspiration for artists and other creative people. He is both masterful and wildly creative.

- **Robert Burridge** paints with energy, emotion, and intuitive spontaneity. His works are richly colorful and are likely to inspire you to grab a brush and express your own visions.

- **Leigh Adams** is an accomplished mosaic artist who uses her talent to inspire the less privileged around the world. Her lovely artwork can inspire anyone who loves texture and color. Like paint, Leigh shows us that glass itself has inherent beauty.

- **Joe Abbresscia** was an accomplished painter of the Southwest landscape, who captured underlying abstract design and used subtle grayed colors that seemed to glow. I had the good fortune to study and teach with him earlier in my career.

- **Flora Bowley** paints freely, passionately, and intuitively through her use of electrifying color and organic forms.

- The paintings of **Angie Wright** use bold acrylic color dripped, dabbed, and woven into Abstract Expressionist landscapes and animal portraits.

- **Geri Schonberg's** abstractions are personal interpretations of the physical world. Her beautiful, expressive compositions are achieved through layers of various pigments, mediums, and papers.

- **Carol Roullard** shows us an aspect of the world we usually don't get to see. She uses microphotography to record the beauty of the microworld, then manipulates and colors the images. Her printed enlargements on aluminum substrates glimmer and glow and suggest otherworldly landscapes.

- **Barbara Katz Bierman**'s paintings of ladylike women and flowers are exuberant, expressive, and free-spirited.

- **David Napp** uses soft pastels to create paintings that shimmer with strokes of color while depicting traditional subject matter.

- **Svenja Jodicke** paints in watercolor to create breathtaking portraits of the human eye, which she believes is the soul of one's inner beauty.

- The lively collages of **Ulrica Bell** display bold colors and innovative patterns.

- **Susan Seddon Boulet** depicts Native American themes in dreamlike compositions. She incorporates her personal mythology into her art and uses inks to achieve haunting muted colors.

- **Pamela Fong** uses free-spirited brushstrokes and colorful patterns to blend Asian historical graphic subjects with a contemporary take on abstract art, resulting in a style all her own. Her "fluid art" speaks to me.

- ✦ If you like texture and vibrant color played against subtle color, you'll appreciate the palette knife landscapes of **Debra Hintz**.

- ✦ Minimalist artist **Alison Jardine** captures the beauty of discarded consumer materials in bas-relief, thereby juxtaposing the transitory with the permanent. She creates gorgeous and intriguing paintings.

- ✦ **Giselle Denis** paints large-scale forests with paths that beckon you to take a walk and smell the fresh colors.

- ✦ If you love pale colors softly blended into pale colors, look at the paintings of **Kristin Lee Hager**, who applies several thin layers of color in a method called "veil painting."

UNCOMMON ART SUPPLIES

Imagine what you can repurpose to function as an art supply. Anything that can be dipped in paint and applied to a surface for making marks is a brush. Anything with interesting shapes and colors can work in a still-life setup. Anything small enough to be glued onto a substrate is a collage element. Keep an open mind about substrates; anything flat enough to paint on is a substrate.

Let your creative mind take over when searching for uncommon art tools. Your discovery and adaptation may lead to an important new style in your artistry. Here are some of my favorite places to look for uncommon art supplies:

✦ Scientific supply stores offer eye-catching still-life props, although not intended for that purpose. Gear structures, tabletop windmills, rocks, small telescopes, and more are wonderful subjects to paint. Many fascinating things intended for science lovers have creative art-making potential.

✦ Look through your backyard. Bunches of grass and plants make brushes that create unique marks, and seed pods work well for stamping organic textures onto canvas or paper. Leaves make great templates for creating rubbings onto paper. My aunt used to bury wood panels in her backyard for months to unearth later so that she could use the weathered surfaces for paintings.

✦ There are stores that carry tiny art supplies, such as half-inch palette knives. These create delicate textures that typical palette knives cannot achieve. You'll find miniature canvases, frames, tiny-detail paintbrushes, flat wood surfaces, and more for small-scale artwork.

✦ Stores that carry collage and assemblage supplies have amazing bits and pieces to get your creative juices flowing. You'll find artsy printed papers, gorgeous rice papers, expressive paper dolls, die-cut shapes, and special adhesives.

✦ Don't avoid craft supply stores. Rubber stamps and specialty inks can be adapted to fine art paintings in wonderful ways, and all sorts of materials and novelty paints can be used in serious artistic expression.

✦ Dollhouse supply stores offer a treasure trove of things to put to new uses for art statements. There are small-scale wallpapers, three-inch rugs, dollhouse clocks and chairs, and bas-relief brick sheets. Surrealists will enjoy browsing through their catalogs.

✦ There are online sources for copper and metal arts. If you like the look of metallic objects, consider painting or etching onto copper and aluminum sheets and die-cut shapes.

+ Jewelry-making suppliers have exciting materials. I use all kinds of beads and findings in my assemblage pieces. Some beads are works of art unto themselves, and they add visual depth to my work. Strings of seed beads can be used for line work, and flat-back cabochons can become tiny canvases.

+ Model-railroad supply stores are among my favorite places to search for art materials. There are fabulous pigments for creating weathered effects and mediums for creating beautiful rusty surfaces. You'll find miniaturized outdoor surfaces, such as cobblestone, grassy ground cover, and brick walls to use in collages. Tiny props, such as trees, road signs, and benches are absolutely magical. Model railroad suppliers also offer tools especially for painting and texturing small areas.

+ Hardware stores have spackle, silicone extruders, specialty paints, and paint finishes. I'm a big fan of the color swatches you can collect from their paint department to use in artsy ways. I also look for interesting pieces of screen, chain, wood panels, wood dowels, and all kinds of materials that the creative mind will see as unique substrates.

+ Online fiber art supplies and blank silk and cotton scarves are great substrates for painting. They also have specialty inks and paints that are worth exploring.

+ Check out your local dollar store. I buy brushes and cut the bristles into interesting configurations. I also use pastry brushes, scrub brushes, and toothbrushes. Use foam brushes for making specialty brushes by pulling off the foam and securing strips of fabric or "whatever" to the handles with rubber bands. Feather dusters make great brushes. Some artists buy powdered eye shadow to use as soft pastels (but the pigments may not last for eternity). Party supplies and doilies provide collage elements, and you'll discover new options for substrates in the auto supply and kitchen sections. For only a dollar, it's fun to see what works.

+ Discarded packaging and other discarded bits and pieces often make wonderful collage elements, surfaces for paintings, trays for mixing paints, texture-stamps for applying paint, and templates for rubbings. I once received a gift I had no use for, but the packaging for it had Styrofoam™ squares with surface bumps that I used as a stamp to add texture to a painting; I sold the painting for hundreds of dollars. So that useless gift became one of the most precious presents I ever received.

+ Swap meets, flea markets, antique shops, and thrift stores are hunting grounds for treasures such as vintage still-life props, collage materials, old books on art, and, if you're lucky, old art materials—which are usually superb quality—used or not.

OTHER THINGS WORTH EXPLORING

✦ There are color associations that forecast color trends for the home decor and fashion industries. It's interesting to see how color preferences have changed over the decades and to be aware of current color sensibilities. I'm not suggesting that artists be concerned with commercial appeal as they create, but there may be cases where you want to know.

✦ Interior paint manufacturers often offer information about color harmonies and trendy color combinations. If you wish to sell art for the home or office, this information could be of value.

✦ YouTube abounds with videos that teach every possible technique with every possible medium. I've learned a lot from viewing some of them. Search YouTube for a material you'd like to learn about or ways to improve your skills. You will stumble upon all kinds of exciting information you didn't know existed.

✦ Wherever you live, there's probably a local art association you could join, and there are many art groups online. Some are general and others specialize in a medium, such as watercolor. It's often helpful to join one or two art groups for camaraderie, a chance to show and sell your work, and for the exchange of information about all things art and artists.

Thank you for reading Creative Approaches to Painting. *I hope you have found inspiration and helpful ideas to use in your work. I have offered you the best of my ideas, but this book is far from complete. Add your own ideas as you follow your artistic path.*

Your feedback, comments, and suggestions are most welcome. Let me know how you put your ideas to work in your studio. I would love to hear from you.

Creatively yours,

Marjorie Sarnat

msarnat@me.com

A Lifetime Passion for Art and the Creative Process

Marjorie Sarnat is an alumna of the School of the Art Institute of Chicago and earned a BFA degree from Eastern Michigan University. She studied with noted painter Joe Abbrescia, for whom she taught art in his acclaimed Chicago art school. She's an award-winning painter and mixed-media artist whose works are in collections worldwide. Today Marjorie is a permanent exhibitor at the Judith Kaufman Gallery inside the Historic El Portal Theatre in North Hollywood, California.

Marjorie's artwork incorporates her love for painting from life with her passion for color and texture. This focus led her to an early career as a textile designer. Her skill with drawing the human figure combined with her innovative ideas led her to a prominent career designing collectible figurines, music boxes, and crafts.

Marjorie is a bestselling author and illustrator of over a dozen books on art and creativity. She is cofounder of Jr Imagination®, a publishing company whose books and games encourage creativity in children and adults.

Marjorie's bestsellers include the *Creative Cats Coloring Book* and *Owls Coloring Book*, together which have sold more than two million copies and have been translated into 18 languages. These sales have catapulted Marjorie into the exclusive company of authors having two books listed throughout the entire year on the *Publishers Weekly* Bestseller List after release in Spring 2015. Her fanciful illustration style is influenced by her love of patterns and a lifetime of collecting vintage illustrated books and ephemera. Her affinity for all things nostalgic finds its way into Marjorie's imagery.

Marjorie lives in Southern California with her designer husband, artistic daughter, creative son, and three fun-loving dogs.

Where to find Marjorie

WEBSITES

Design and Illustration	www.marjoriesarnat.com
Fine Art	www.sarnatart.com
Creative Thinking	www.jrimagination.com

BLOGS

Marjorie's Coloring Journal	www.marjoriesarnat.com/blog
Art Studio Secrets	www.art-studio-secrets.com
Raising a Creative Genius	www.jrimagination.com/blog

SOCIAL MEDIA

Twitter	@MarjorieSarnat
Pinterest	marjoriesarnat
Instagram	marjoriesarnat
Facebook Group	www.facebook.com/groups/marjoriesarnatcreativecoloring
Email List	www.marjoriesarnat.com/for-color-lovers
Amazon Author Page	amazon.com/author/marjoriesarnat

Notes and Ideas

Notes and Ideas

Notes and Ideas

Notes and Ideas